– Parting The Veil –
The Art Of
Nene Thomas

CHIMERA PUBLISHING

HAMILTON, NEW JERSEY
2005

Parting the Veil: The Art of Nene Thomas

Art: Copyright ©Nene Thomas 2005
Introduction: Copyright ©Bruce Coville 2005
First Edition: Copyright ©Chimera Publishing, 2005. All Rights Reserved

Editors: Norman Hood and E. Leta Davis
Design and Layout: McNabb Studios for Chikara Entertainment, Inc.

Limited Edition
ISBN 0-9744612-790000
Hard Cover
ISBN 0-9744612-890000
Paperback
ISBN 0-9744612-990000

Chimera Publishing
—Hamilton, New Jersey

Visit our website at
www.chimerapublishing.com
E-mail: norm@chimerapublishing.com

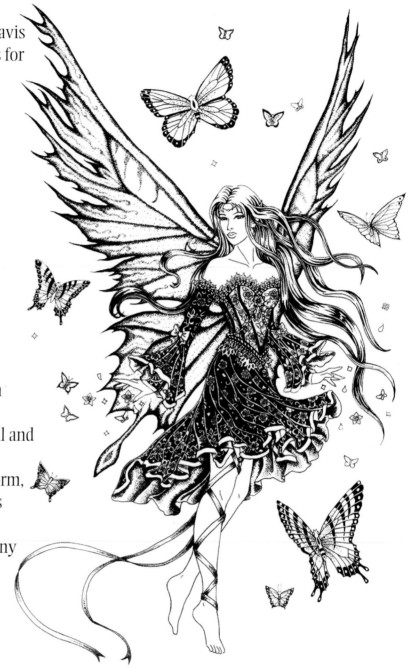

First Printing: July 2005
10 9 8 7 6 5 4 3 2 1

Printed in China by
Regent Publishing
Services Limited.

Contact RegentNY2@aol.com
for additional information.

Dedication

I dedicate this book to my husband, Steven C. Plagman. Your unswerving faith and love has helped me grow not only as an artist but as a person. I would be remiss in not acknowledging that you are an integral part of every painting I create.

You are everything to me.

Artist's Foreword

I have loved art for as long as I can remember. I can think of no greater gift than to take an image or an idea and express it in a fashion that others can appreciate and understand--even love. Whether that expression takes the form of the music that you hear on the radio, or as a book that you can't put down, or as a movie that you never get tired of seeing no matter how many times you watch it, artistic expression is a gift that the creator gives to his or her audience. When I was younger, I used to look at books of art by the masters, and wish that I too could create something of such sublime beauty that others would view my art as a gift as well, and would draw inspiration from it the way I did with the masters. I am a long, long way from achieving this goal, but even today it is my fervent hope that someone, somewhere, will be inspired by my work—inadequate as it is--and will use that inspiration to create art of their own.

It is a rare thing to be able to make a living doing the thing you love the most. I didn't start out as a professional artist; I started out as an art lover who wanted to be an artist. I had to work at it. I didn't have a lot of talent, nor was I exceptionally gifted. Almost everyone around me, including other artists, warned me that I would most likely end up a stereotype: a starving artist. And the truth is, sometimes I did live the stereotype. But the thing that kept me going was the desire to succeed. To show the world what I saw, and to give the world the gift that others had given to me.

Perfection is an ideal that can never be truly realized. It is a goal that can never be obtained, no matter how hard you strive for it. Yet it is this striving that makes us better than we are, and forces us to create beyond our ability. Achieving perfection is impossible, but sometimes--just sometimes--we can reach excellence. Looking at the images in this book reminds me of the triumph and the agony that each of these paintings has brought to me. They remind me that no matter how much I draw--how much I paint--I still have a long way to go before I can truly consider myself an artist. But I am striving. I'm setting aside my successes and failures alike, and reaching for that spot within me that exists within everyone: that indescribable place that allows such beauty to be expressed. I've been there a precious few times before, and believe me when I say that it is a wonderful place to be.

This book is my gift to you, fellow art lover. May you draw inspiration from it, and may you use that inspiration as fuel for achieving dreams of your own. You have it in you: all you have to do is strive for it.

Nene Thomas

A GLIMPSE BEYOND THE VEIL . . .

I know a little about beautiful, detail-obsessed, cat-dominated painters of exquisitely rendered fantasy images, mostly because I'm married to one.

Not, I hasten to add, Nene Tina Thomas.

But as I studied Nene's art and began to learn more about her, I experienced an eerie sense of familiarity. Writing in her live journal (to be found at her excellent website, www.nenethomas.com), Nene once described spending an entire day painting the details on thousands of tiny feathers. Reading that, I immediately had a flashback to a sequence of conversations I had with my wife, Kathy, when she was working on an illustration for our first book. The picture showed a giant holding a "bouquet" of apple trees.

"You're not going to draw in all the separate leaves, are you?" I asked somewhat nervously, concerned about both her well being and the deadline.

"Of course not," she replied.

When I came back to the studio a few hours later she was patiently and happily outlining each leaf.

"Um you're not going to shade them all, are you?"

"Of course not!"

It will probably come as no surprise to you that by the time the picture was finished, the leaves had all been carefully, individually shaded.

Certainly I would not be surprised to discover that Nene's husband, Steve, has had an occasional conversation like this with his wife, at least until he learned better. People like Nene—and thank the powers that we have them!—work in a kind of hyper-focused state that lets them live inside the image they are creating. It's as if they are visiting another world in order to bring back reports to those of us not privileged to go there ourselves.

And what a world it is. As a child of the northern forests, I recognize the bare winter branches that form the background of so many of Nene's images—recognize them for the clarity and fidelity with which she has rendered them. What she has added is what I never saw myself but always suspected was there and longed to see, namely the ethereal and fantastic beings that populate those woodlands.

One of the things I love about Nene's paintings is that there is so much to see. These are pictures you can spend time with—and, having spent time, you can revisit them and still find new things. Take Chance Encounter, one of the images in this book. First, of course, you see the central figure and the small black dragon hovering above her. You note the sense of connection between them, and your mind starts to ask questions, to build a story. What kind of dragon is it? Will this be but the meeting of a moment or will they form a bond? Is the dragon merely curious or is it bringing a message, perhaps even seeking her help? What more might be in store for these two? Some pictures are worth a thousand words. This one could easily spin its way into being a full novel.

As you continue to look, or when you return for another visit—for these are paintings that you can visit, not merely look at—you begin to note the details: the extraordinary delicacy of the horse's bridle, so real that you can imagine the feel of it beneath your fingertips, or the finely rendered feathering of the hairs on its legs. And always, behind it all, the winter forest, which stretches into a misty distance that makes you long to enter it, to discover what else is back there (though, of course, it could be that little dragon's mother).

It's only when you put it all together and step back from the magic for a moment that you begin to realize the time (not to mention the obsession with detail) it must have taken to create such an image. And then when you consider the number of images in this book . . . well, the mind boggles. Nene's statement, "I HAVE to paint—it's a compulsion." helps to make sense of it all. How else could this wealth of detail have come to be?

Nene got her start as a professional by painting cards for the Magic gaming system. It was a good training ground, I suspect, but hardly a large enough canvas for her vision and energy. You can also see in her work, sometimes quite obviously, Nene's love of anime. I suspect, too, that she has a fondness for the work of Kay Nielsen, though that is only conjecture.

To continue with the conjecture—Nene must, one thinks, be light of spirit. Only consider how much of her work is filled with things in flight, with butterflies and swirling leaves, owls and dragons, and the faeries themselves, often happily suspended in midair, especially in her anime styled paintings. Her sense of play and whimsy comes out in some of these, and it is clear that her inner child is alive and well. But her vision stretches to the heroic, the romantic, and even the starkly ferocious. (You know, for example, that the dragon in "Omen" would eat your heart without a qualm).

Of all the images in this book, my personal favorite is Moon Dreamer, a work that is filled with pensive magic. The background seems more simple than those found in many of the other paintings (though in reality its expanse is infinite), yet somehow it's a picture you can get lost in and can become, if you let yourself fall into it, as contemplative as the central figure.

You may well find a different favorite. It will take you a while to do so, for there are enough images waiting in the pages that follow to sate even the hungriest imagination.

Those of us who love fantasy often have the sense that there is a magical world waiting just beyond the veil. Nene Thomas has very kindly parted that veil for us and given us a glimpse of the wonders waiting for us on the other side.

Just turn the page and you'll see what I mean . . .

Bruce Coville
Syracuse
February, 2005

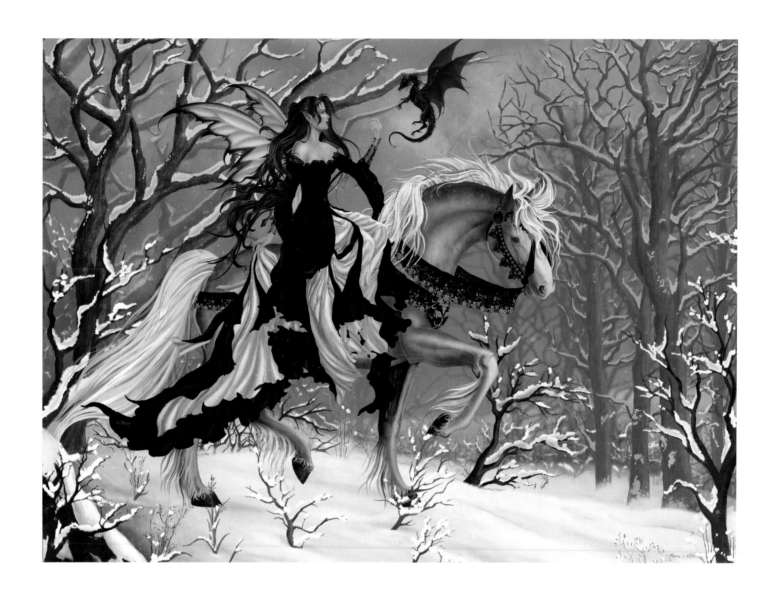

A Chance Encounter

When I started painting *A Chance Encounter*, I didn't realize how difficult it would be to complete. The problem wasn't the intricate six-sided cloth: it was the background. I wanted to convey a sense of isolation, deep in a snowy forest, and I think I achieved the effect I was looking for, but it took much longer than I expected. As you look at the images in this book, you may notice I also used this character in *Hope*, *Gathering Storm*, and *Storm Runes*. I love this character's design very much, and I often find myself imagining new paintings in which I can place her.

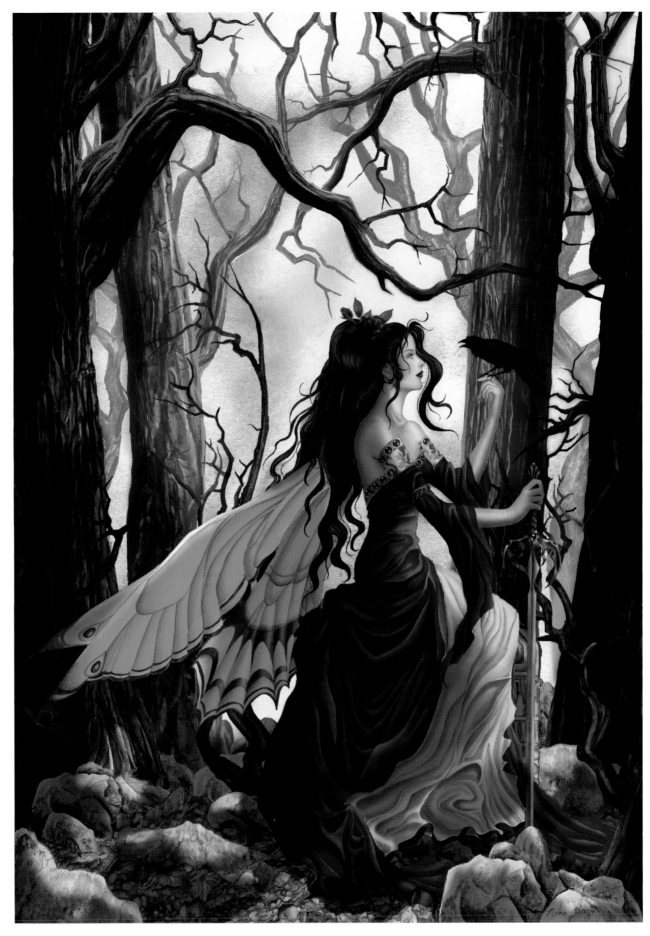

Always

When I finished the original sketch for *Memento*, the woman I had fashioned had black angel wings and was sitting in a graveyard. While I loved the finished painting, I decided that it was too dark to appeal to the general public, so I repainted it. I turned the angel into a faery sitting in a forest and renamed the piece.

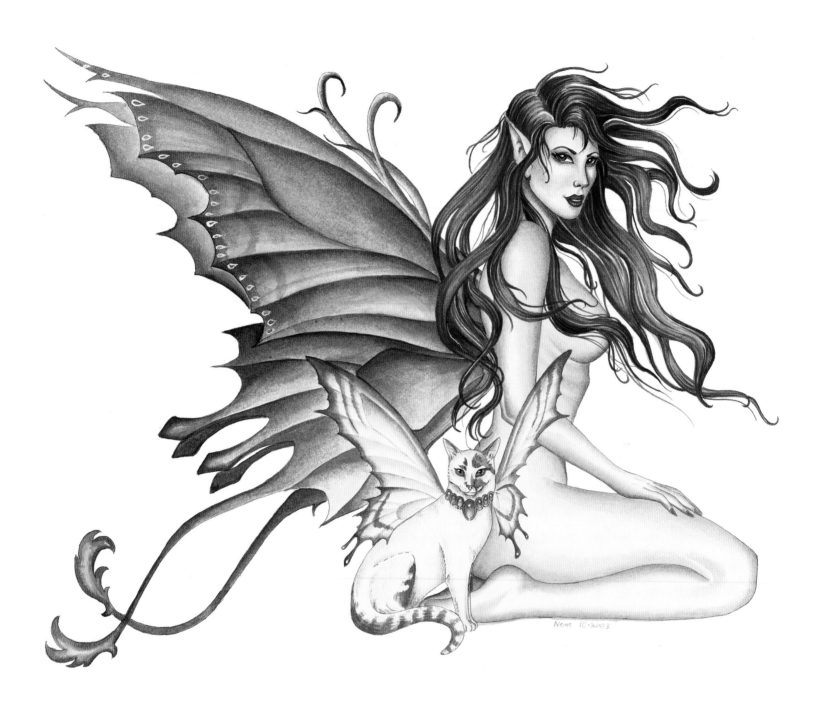

Amber

The cat in this picture is one of my six cats. His name (oddly enough!) is Amber. Amber was a stray cat that had had enough of sowing his wild oats. He decided it was time to settle down, so one day, when I was checking the mail, he ran into my house, through the open door, stopped, and took a good look around. Once he was sure the house was up to his standards, he gave me a look that said, "This will do. Now show me to my room."

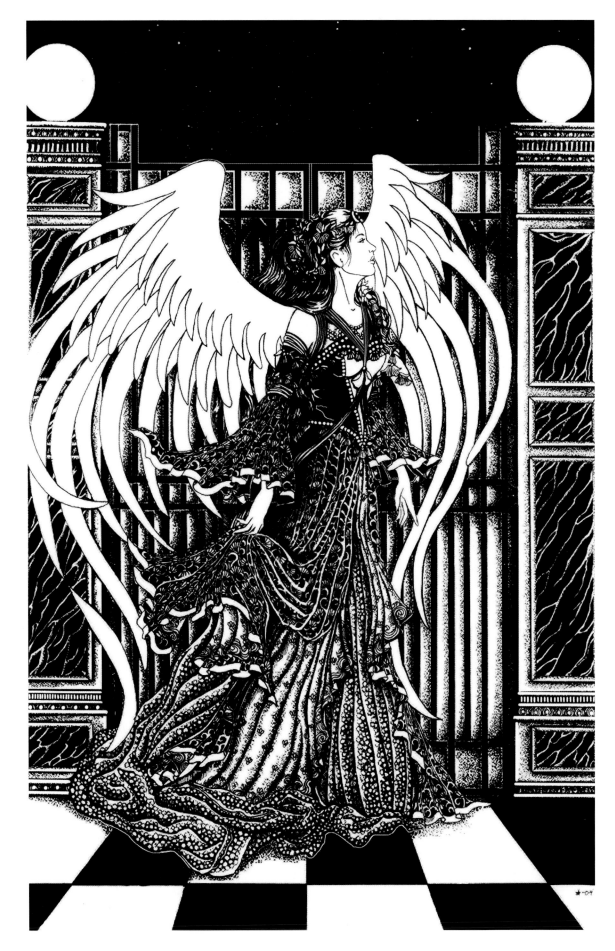

Angel's Gate

I had high hopes for *Angel's Gate* when I finished the sketch, but the finished version didn't live up to my vision. So I placed it on a shelf and forgot about it until Ann-Juliette took it down one day and tightened the original sketch into a very nice pen-and-ink drawing.

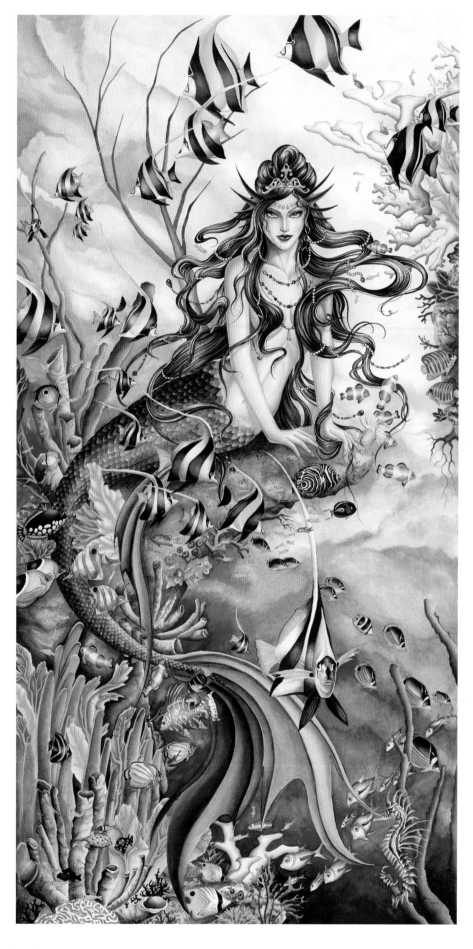

Aquamarine

The fish in this picture are all real salt-water, tropical breed. They aren't all from the same region, but they are real fish, and when I painted this picture, I learned all of their names, just to see if I could.

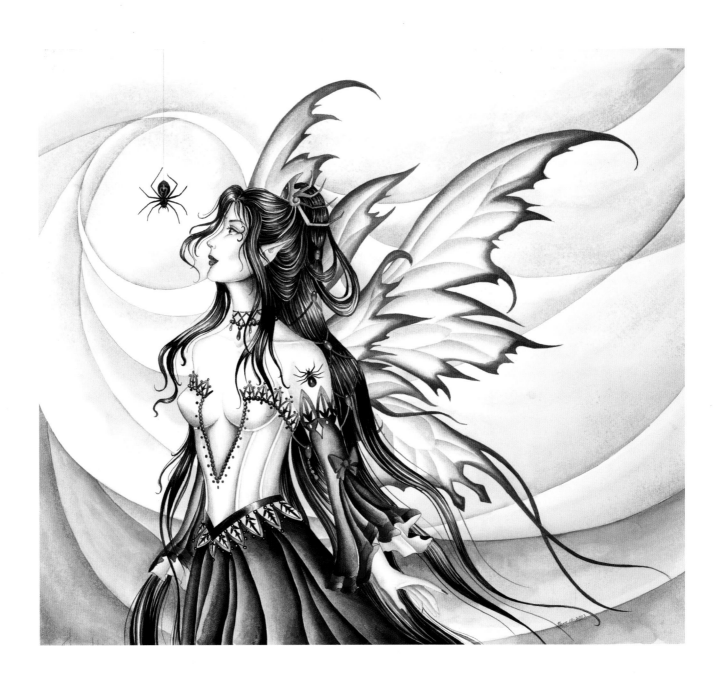

Arachne

For those of you who aren't familiar with Greek Mythology, Arachne was a weaver who boasted that she could weave better than Pallas Athena, the goddess of wisdom. Athena took exception to this boast and transformed Arachne into a spider, dooming her to spend eternity weaving webs and contemplating the folly of angering the gods.

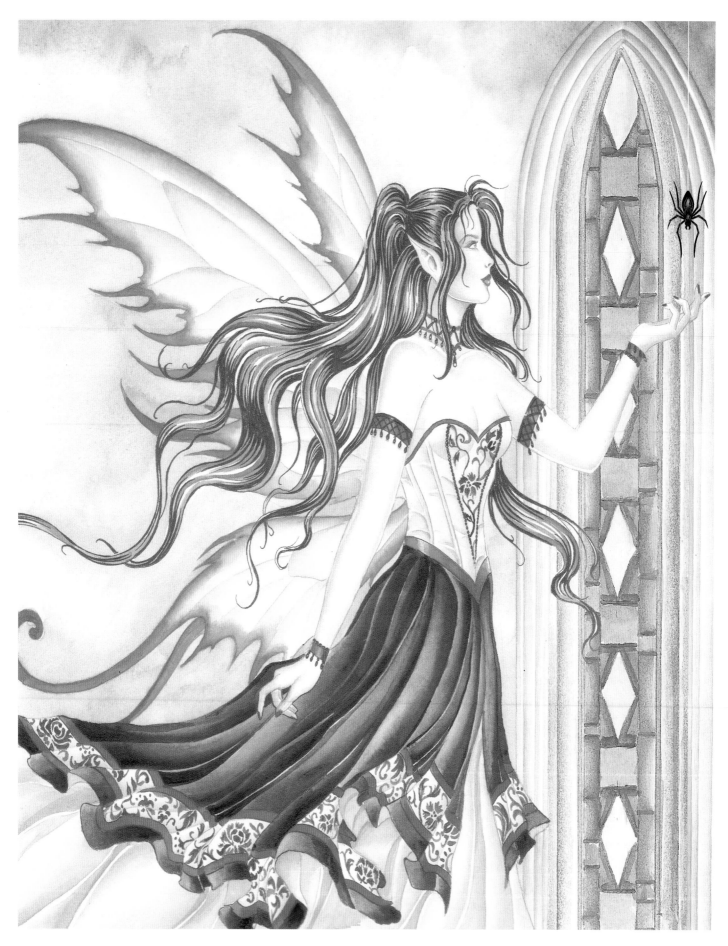

Arachne II: Dark Spider

I have to admit that when I paint an image I'm never quite sure if it will be popular or not. *Arachne* was one of the pieces that I enjoyed doing, but I didn't expect it to be particularly successful. Some time after I painted it, one of the companies that carries my art asked me to paint a companion piece, using the same character. *Dark Spider* is my response.

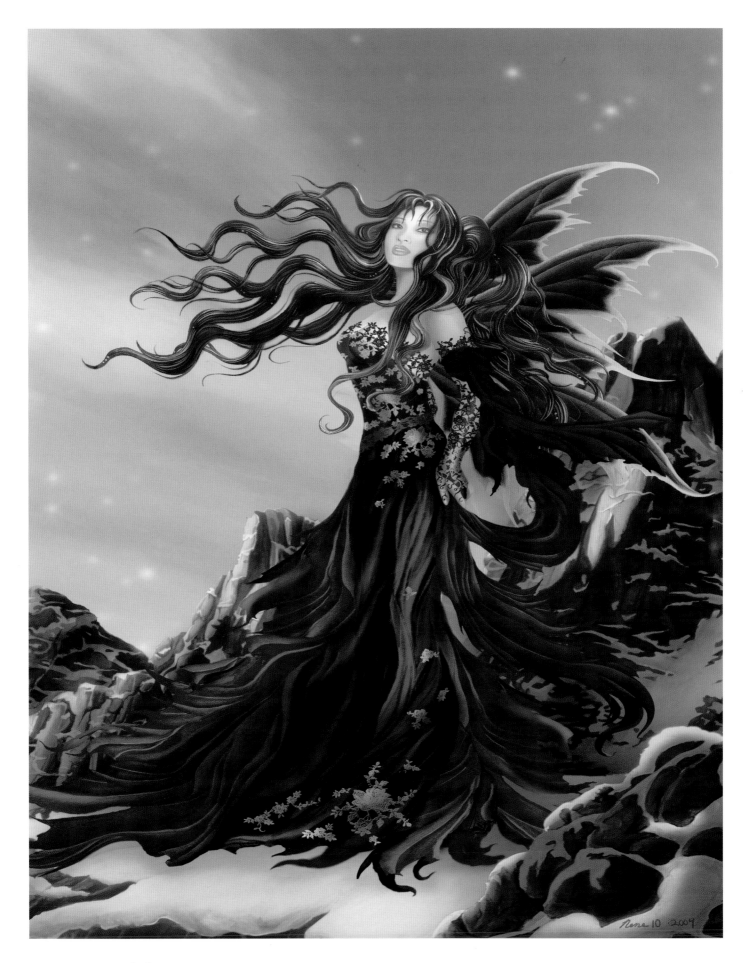

Aria

Normally I don't like to do portrait pieces because it is extremely difficult to get the painting to look like the model. I made an exception for *Aria*. The girl in the picture is a very good friend and fellow artist named Yaya Han, and she is so beautiful that I had to paint her. I was a bit nervous when I showed it to her, but she loved it!

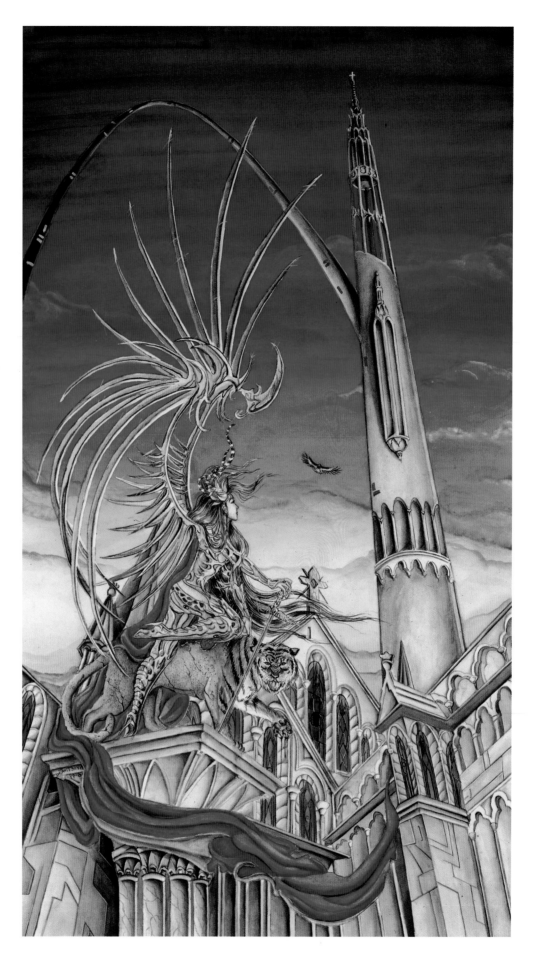

Bird of Prey

I painted *Bird of Prey* shortly after *Knight of Winter*. While I was sketching it, I played around with perspective, trying to find an angle that would make the tower seem like it soared and give the arch a truly vaulted look. This piece was featured on the cover of *Cryptych* magazine, but I never actually released prints of it.

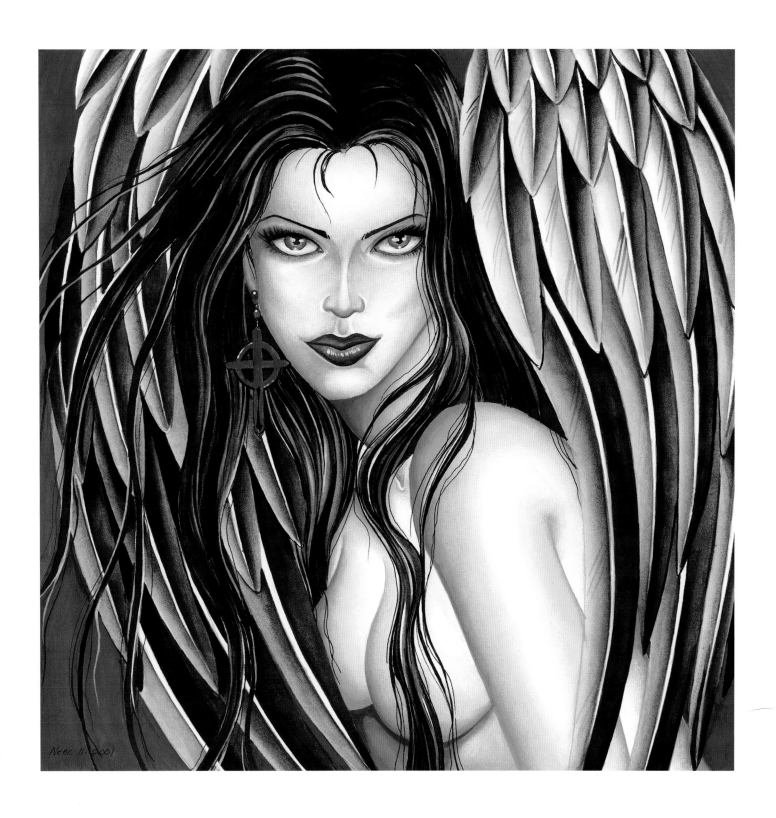

Blood Angel

In the majority of my paintings, I give the central figure an elegant look. I keep the poses demure and the facial expressions soft. This piece was designed to be different. The central figure has a very direct gaze, and there is nothing demure about her.

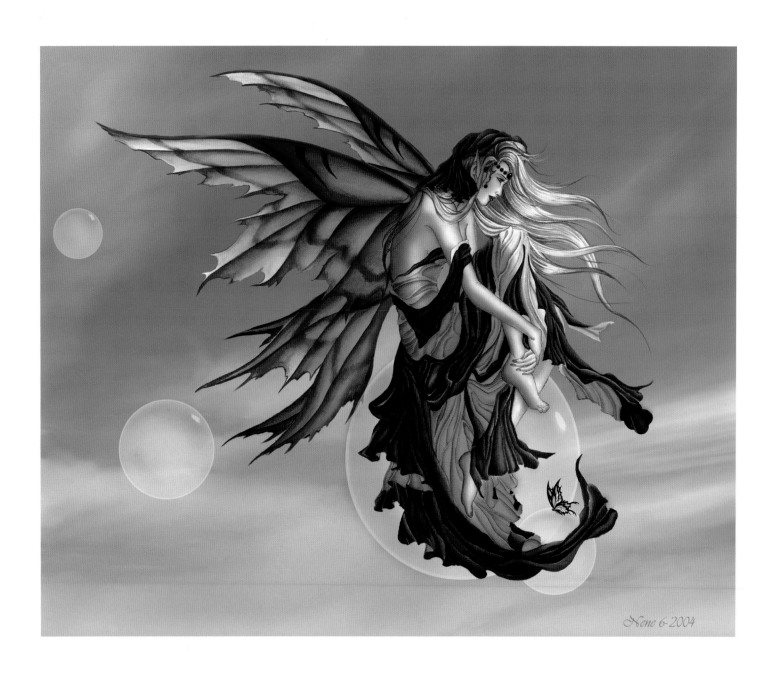

Bubbles and Butterflies #1: Blue Dream
When I develop a painting, I usually try to envision it as part of a series rather than as a single piece. *Bubbles and Butterflies* was designed as a series of figures sitting on bubbles that had very simple backgrounds and a lot of cloth. In *Blue Dream* I wanted to display strength through simplicity, so I deliberately kept the background simple. The figure really seems to be floating along, daydreaming.

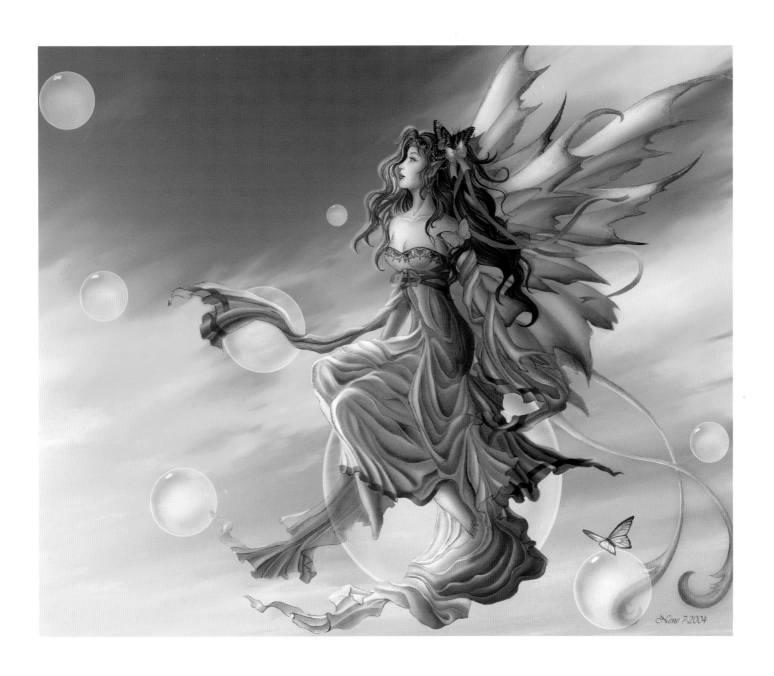

Bubbles and Butterflies #2: Daybreak

This painting is the second in the *Bubbles and Butterflies* series, and I got a little more aggressive with the lighting while I was painting it. I wanted the background to be a little more elaborate than the one in *Blue Dream*, but I still wanted to convey a feeling of simplicity.

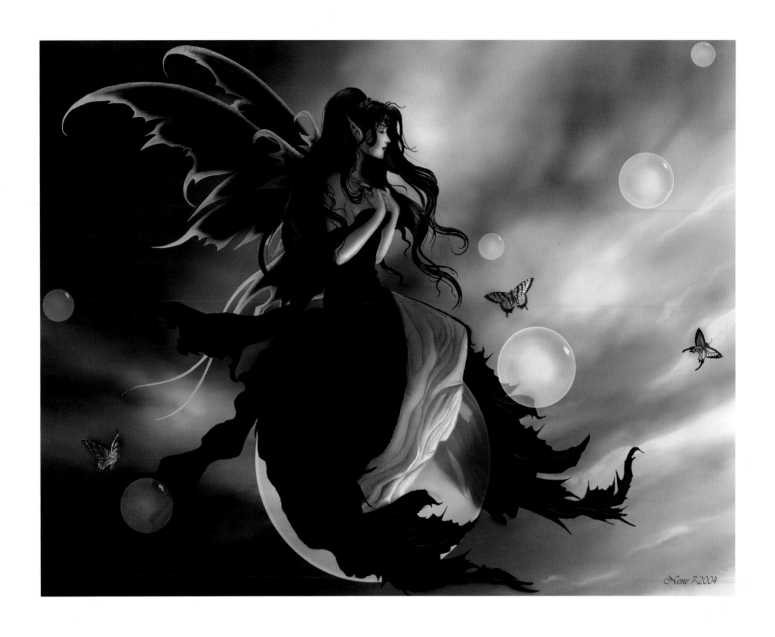

Bubbles and Butterflies #3: Gathering Storm

Gathering Storm, like the first two paintings in the *Bubbles and Butterflies* series, employs a simple background, dominated by an elaborate figure. The black and beige dress compliments the figure's warm gray skin very well, and the wings are as near to perfection as I could hope to get them. I also love her hairstyle. The effect created by the topknot, held in place by a jeweled hairpiece, greatly improves the image.

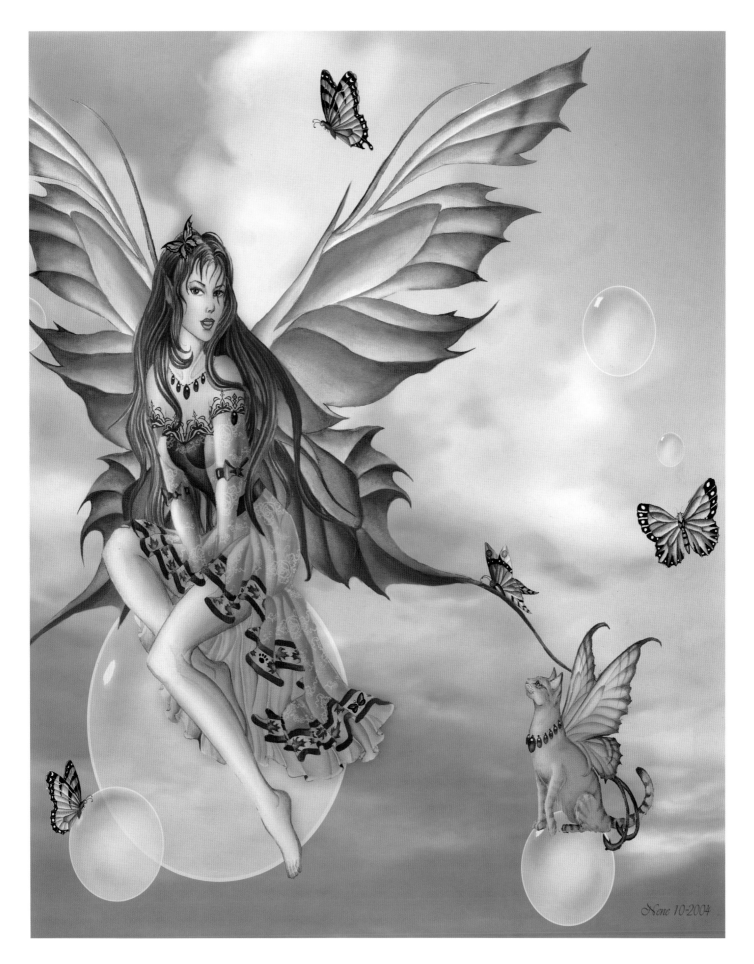

Bubbles and Butterflies #4: Purple Lace

Sometimes a series will take on a life of its own, and I end up adding more and more images to it. *Bubbles and Butterflies* has become that kind of series. Every time I think I am finished, inspiration hits, and I'm suddenly working on another piece for it. Luckily, this series is a genuine pleasure to paint.

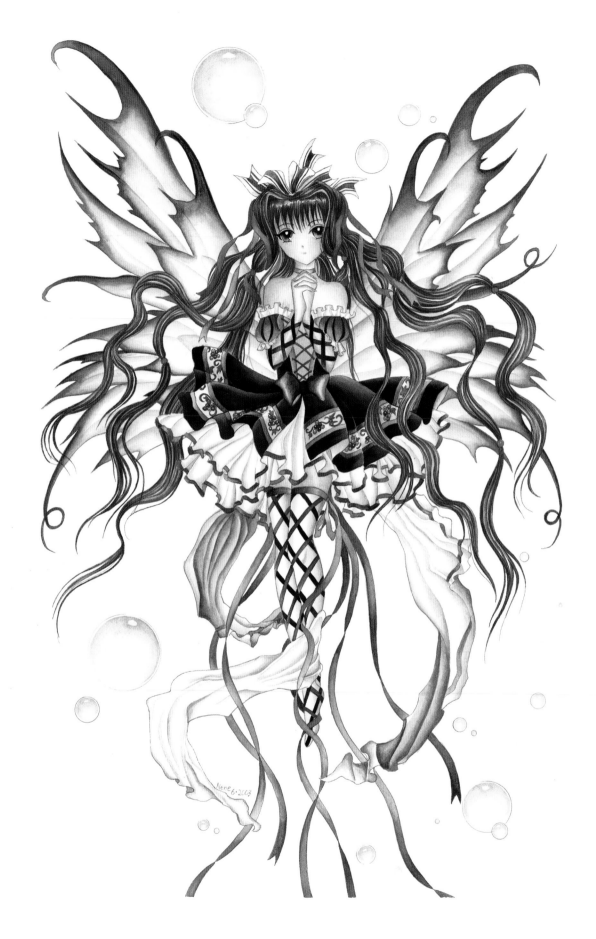

Burgundy Wine

This image is from my series of Japanese Anime inspired faeries. My anime faeries tend to be cuter and more lighthearted than my regular faeries, and I emphasize this by giving their dresses more frills and flourishes. I also love to paint long, very elaborate stockings, and cute stockings are perfect for these faeries.

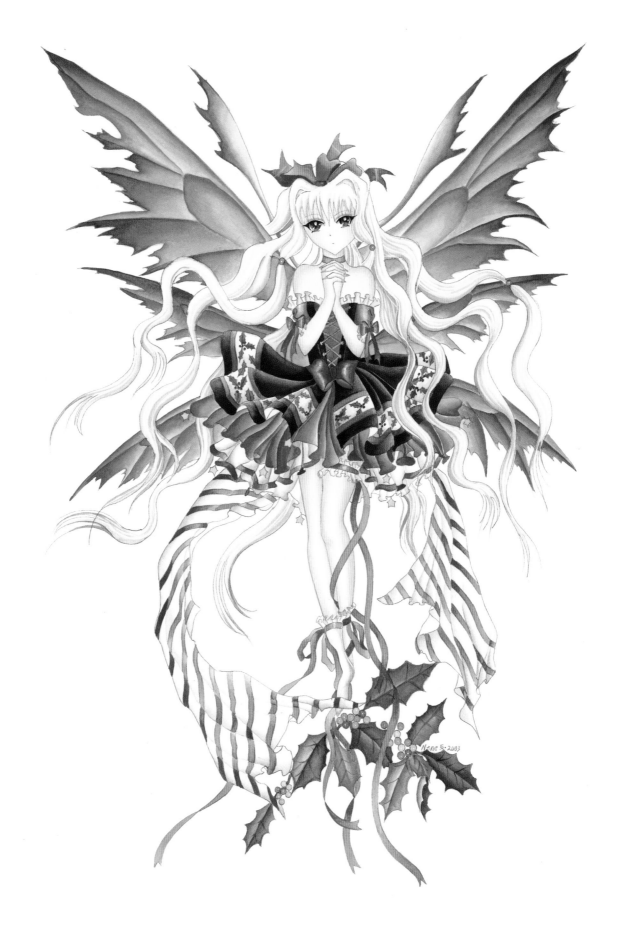

Candy Cane

I usually don't paint holiday-specific designs, but I made an exception in this case. The idea of *Candy Cane* was so incredibly cute that it just had to be painted. Don't look at this painting too long! You'll get cavities!

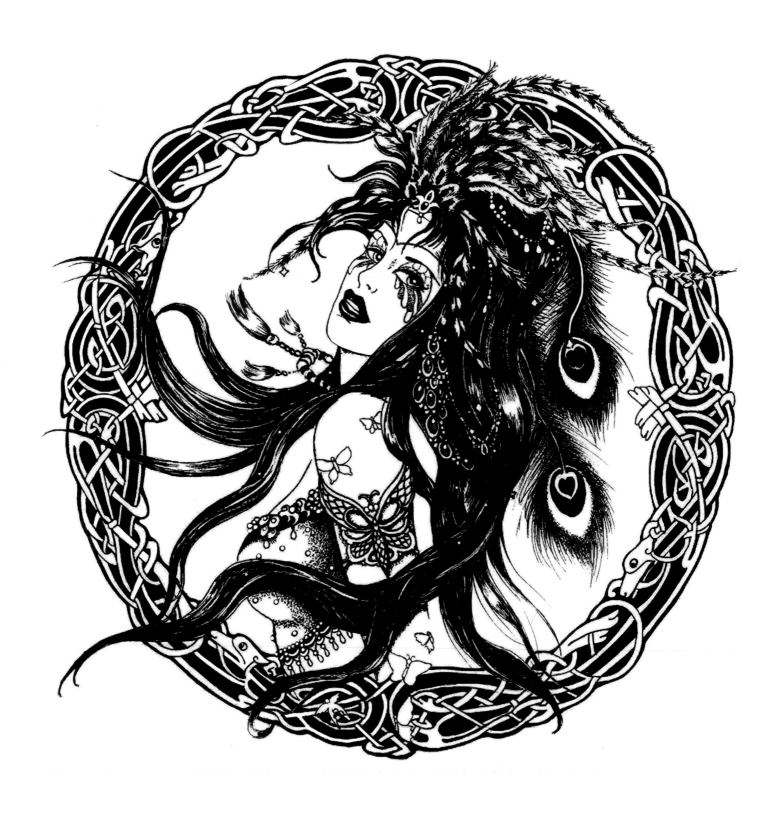

Carnevale I

Not every piece that I sketch becomes a finished painting. In fact, most of my sketches sit on a shelf and are doomed to sit there waiting, unloved and unremembered. When I hired my sister, Ann-Juliette, as my art assistant, I needed to find a way to allow her to practice converting my sketches into a form ready for me to paint. So I pulled out a stack of old sketches and asked her to turn them into pen and ink originals. All of the black-and-white images in this book were penned by Ann-Juliette, and as you can see, she has quite an eye for detail.

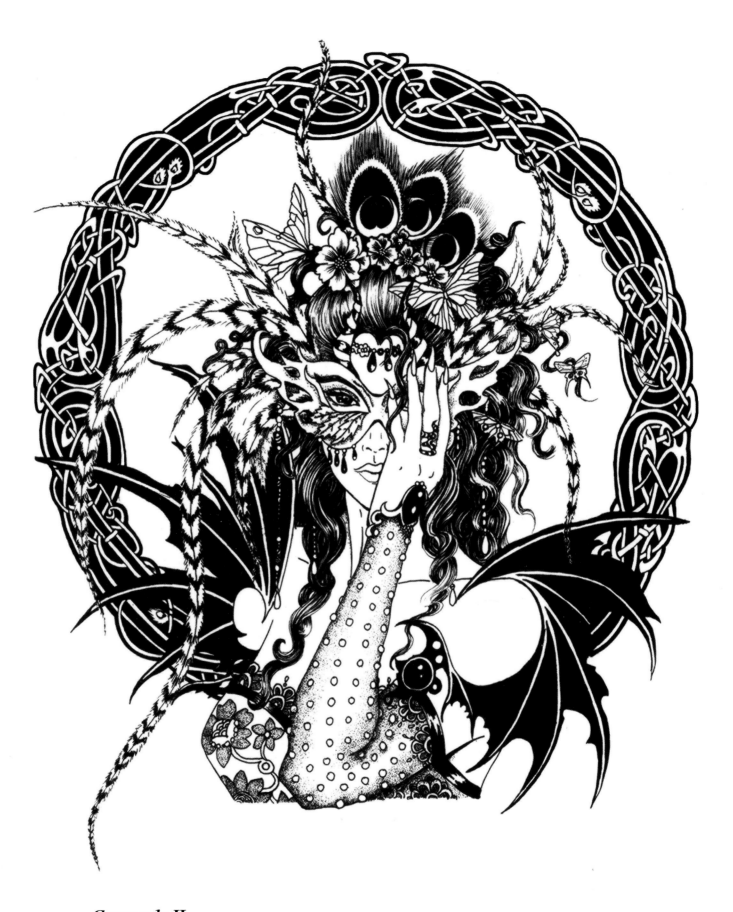

Carnevale II

The *Carnevale* series was something I had planned to do a while ago, but as I looked at the paintings I had completed, I saw that too many of them were simply faces and torsos on stylized backgrounds. So I reluctantly set the *Carnevale* series to the side and began working on large pieces with full backgrounds again. I still like these pictures and am glad that I have a chance to share them, but I still think I made the right decision when I set them aside.

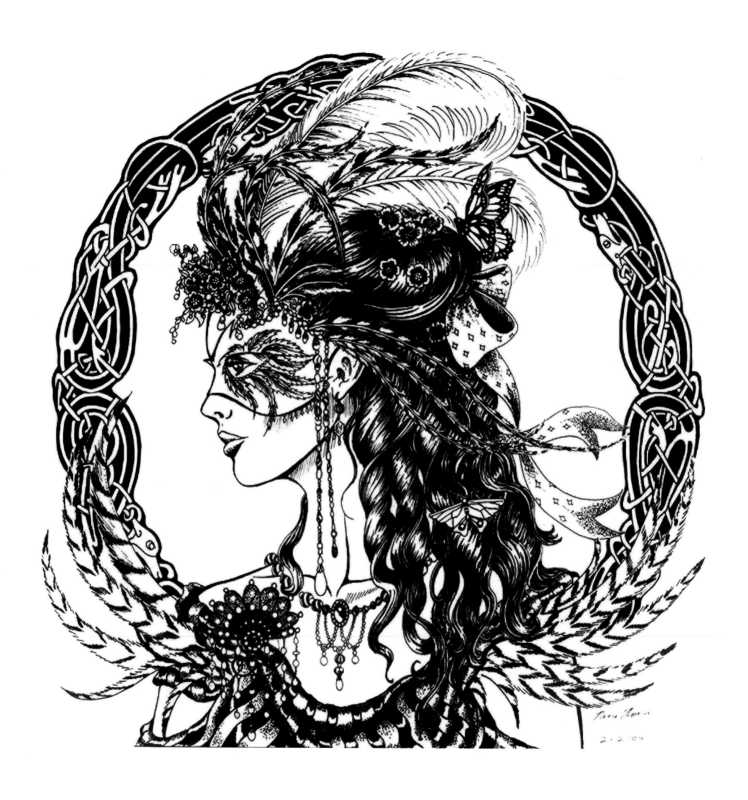

Carnevale III

Of the three images in the *Carnevale* series, this one has the most antique look. The curls, the patterns on the figure's dress, and the feathers are all hallmarks of Victorian styling, and I think that these design elements add up to create a very regal whole. I have to admit, I absolutely adore Victorian styles, and they mesh well when they are spiced up with a fantasy element.

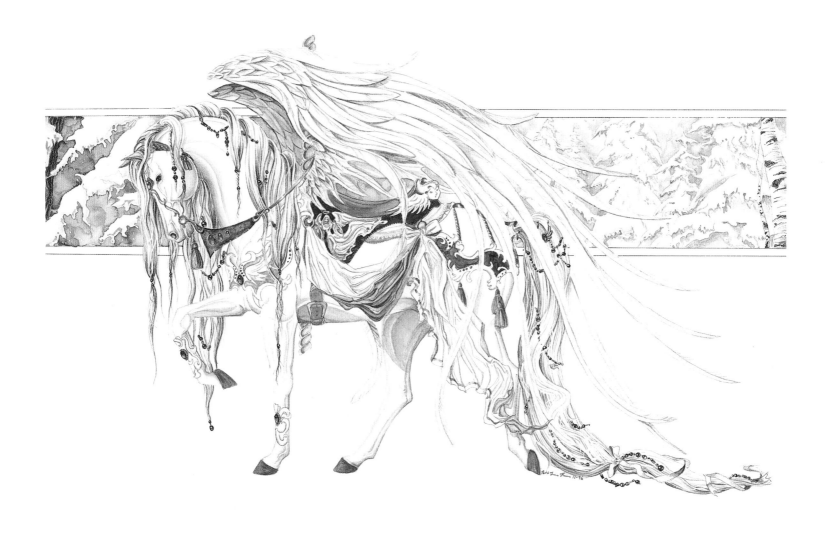

Carousel Horse #1: Angel White

Carousel Horse #1: Angel White is the first in a series of paintings designed to work together to achieve a special effect. When the series is completed, there will be twelve horses in all, one for every month of the year. *Angel White* is the carousel horse designed for January. If everything goes as planned, each subsequent image in the series will fit side-by-side in order, the colors running from white to black, the horses moving up and down like a carousel, and the backgrounds changing with the seasons. If you collect all twelve of the images and line them up in the proper order, you will have a continuous picture of a forest changing through the season.

If you look at the saddle, you will see an angel: the final part of the imagery. Each horse will have a saddle device that incorporates the title.

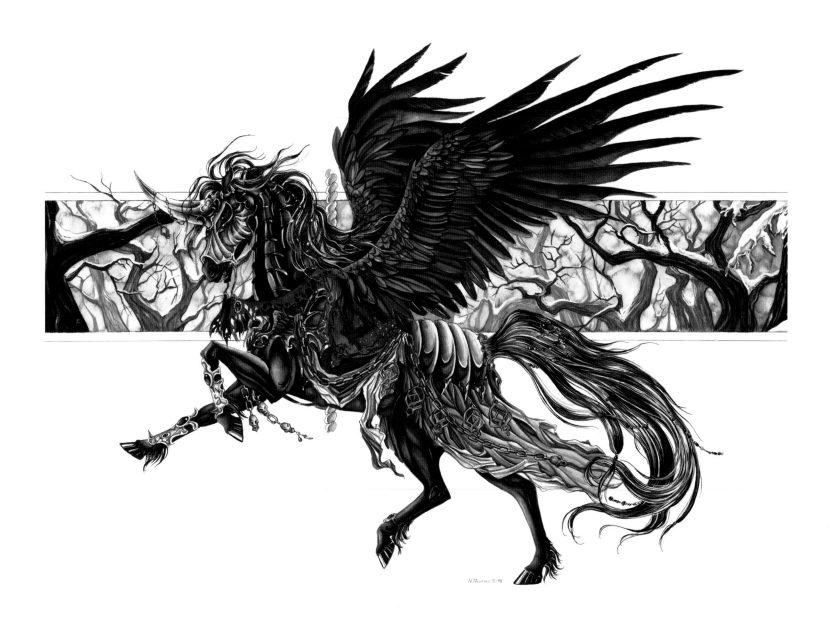

Carousel Horse #2: Raven Black

Raven Black represents December, but it was the second image that I painted for the series. The reason I paint these images out of order is that I prefer winter and autumn scenes to spring and summer scenes, so I'll paint the seasons that I like first, then go back later and finish the series.

If you look closely at this horse, it will become apparent that this isn't a nice horse. His teeth are pointed, the chains around his neck have skulls on them, and the chamfron protecting his head is bladed. The saddle device is a raven.

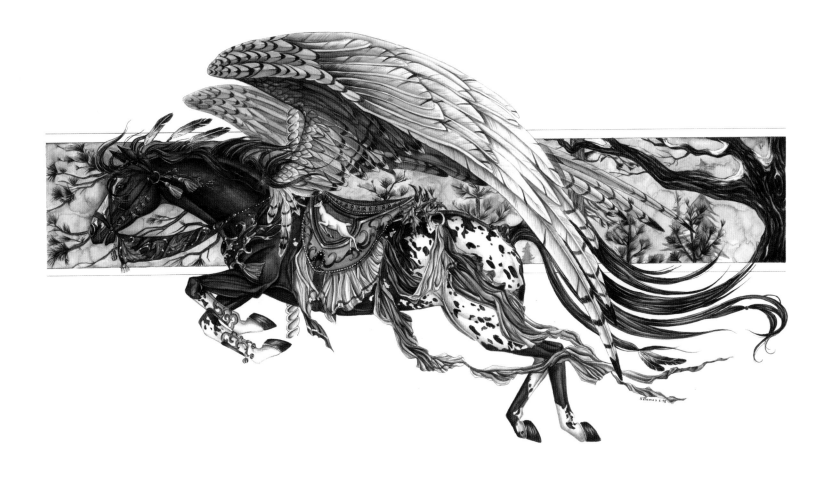

Carousel Horse #3: Hunter Brown

This is the third carousel horse. Hunter Brown represents the month of November and fits to the left of *Raven Black*. The horse is in full flight, and its pose mirrors that of the stag on his saddle.

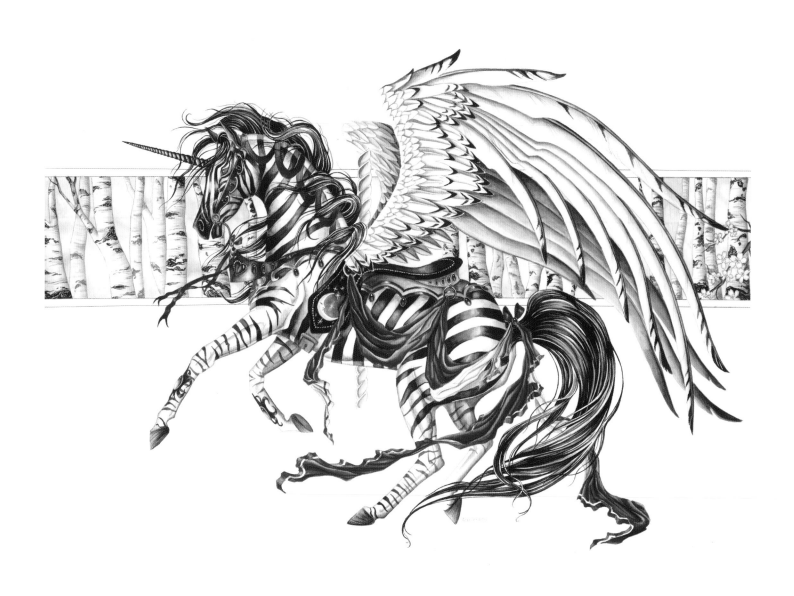

Carousel Horse #4: Moonlight Silver

For those of you who watch Animal Planet, you may notice that this isn't actually a zebra. I think zebras are extremely ugly, so I painted a stallion with zebra colors and hoped no one would notice. *Moonlight Silver* represents the month of February and fits to the right of *Angel White*. Here's a bit of trivia: someone once asked my husband what kind of fantasy creature was this, a Pegasus or a unicorn? Neither. It's a Pegaunizebracornasus was his answer.

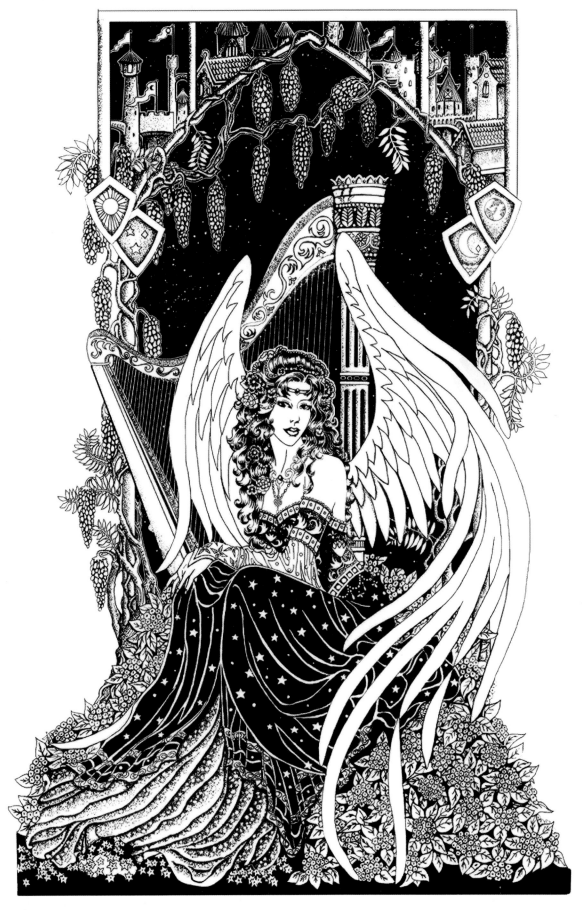

Celesta

I drew *Celesta* years ago, when I was thinking about adding a second set of images to the *Virtues* series. While I liked the way this image turned out, I felt uncomfortable with the idea of continuing an already completed series. Too long much time had passed since I completed *Introspection*. After Ann-Juliette finished the pen-and-ink version of the image, I decided to use the figure in a different painting and created *Interlude*.

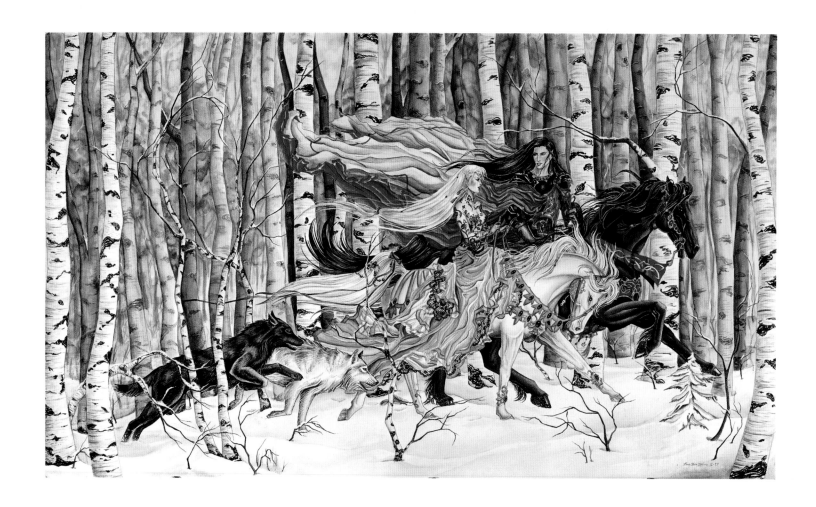

Counterpoint

Counterpoint is my tribute to Bev Doolittle, one of my favorite artists. The horizontal format, the birch forest, and the movement through the trees are all hallmarks of her work, and I tried to capture the same feel in this image. Don't bother looking for any hidden elves in the trees though! That would be over the top, even for an homage.

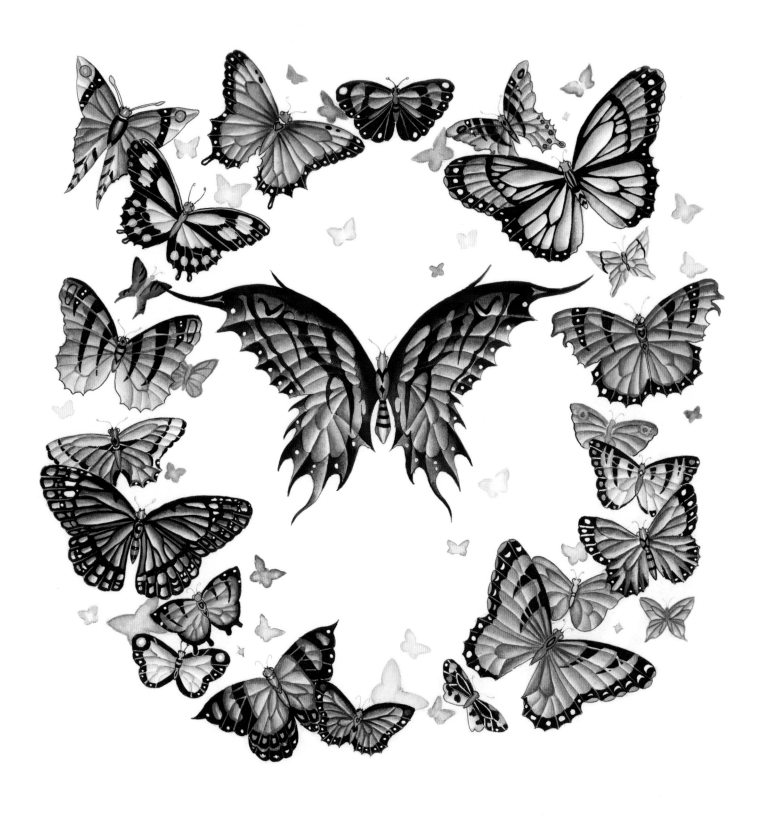

Dark Butterfly Ring

Can you think of anything more beautiful than a sky full of butterflies? This image was created as a sticker design for one of the companies that I work with, but I liked it so much that we actually ran prints of it. One of my fans asked me why I paint butterflies as if they were pinned to a board. Silly person! They aren't pinned down: They're just well-trained!

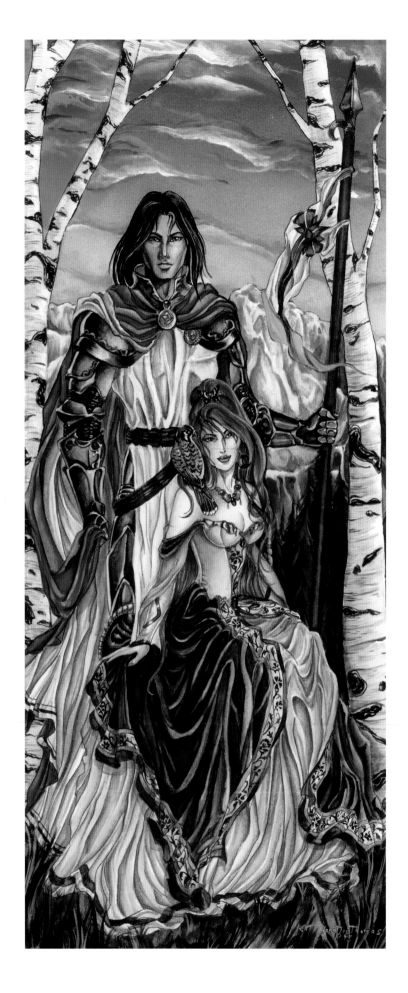

Devotion

I was really happy with the way this painting came out. The colors of the dress are very vibrant, and the knight's armor actually looks like armor. But the outstanding part of this image is the decorative border on the dress. I had played with borders before, but this one really came together, and it set the standard for all of the other frilly dresses that I've painted since.

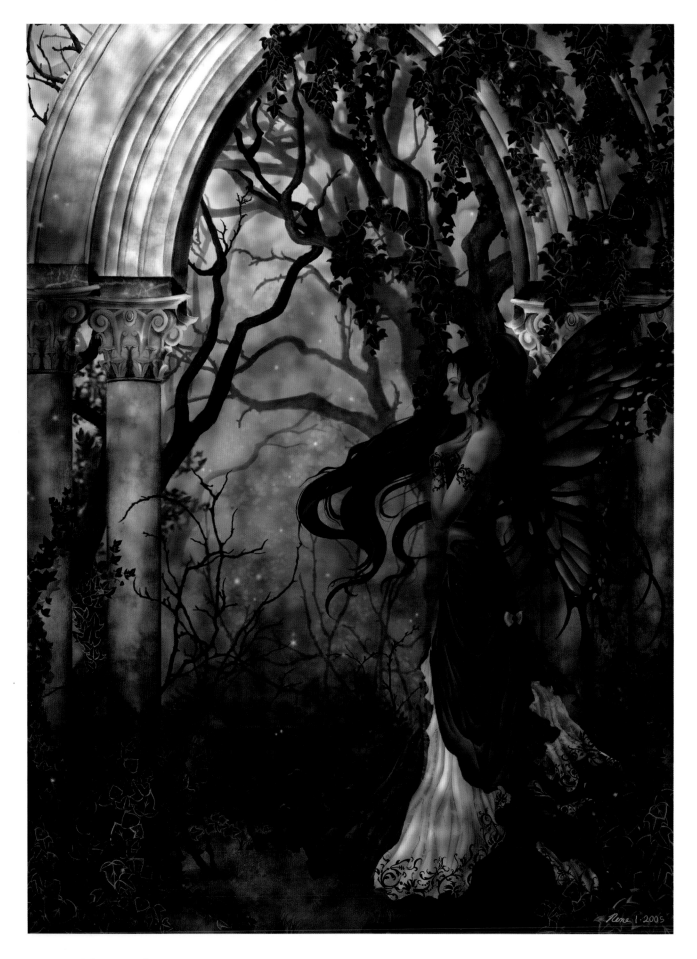

Direwood

Inspiration comes from the most unlikely places at times. My husband loves video games, and I got addicted to watching him play one particular game. One of the areas in this game is a beautiful forest that succumbs to a malevolent influence, and its beautiful foliage has been turned into a twisted mockery itself. The imagery of this setting stuck with me and inspired *Direwood*.

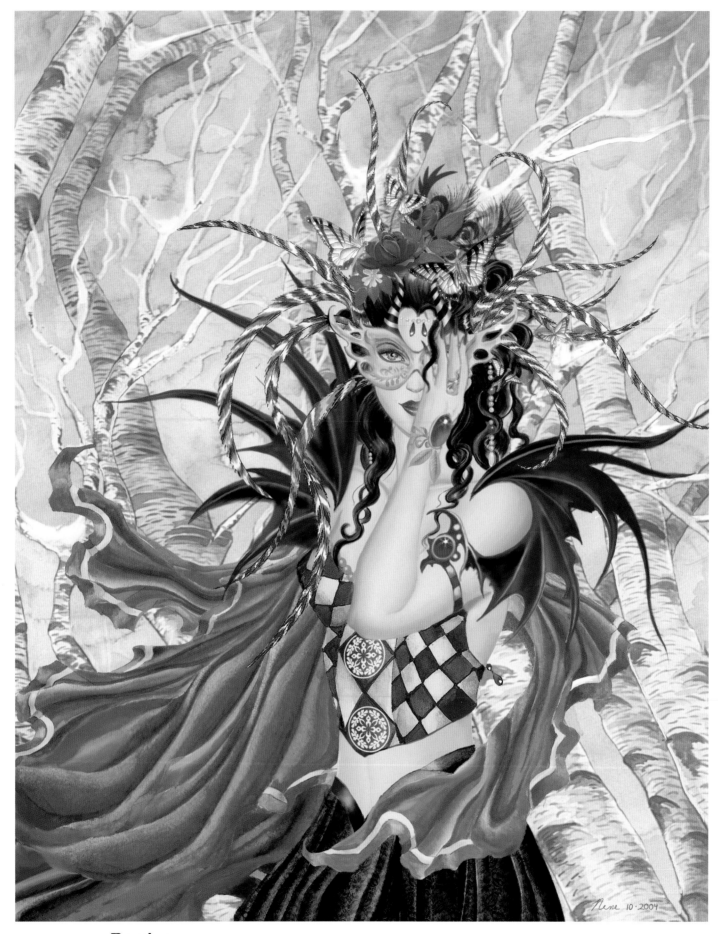

Domino

The original sketch of *Domino* was much smaller than the finished painting, as all I had originally intended to paint was the figure's face and the mask. As I was working on it, however, I decided that I wanted to see more of the figure, so I started over, using the original design as the starting point. The character is from a story that I have been working on for most of my life. The character's name is Aveliad.

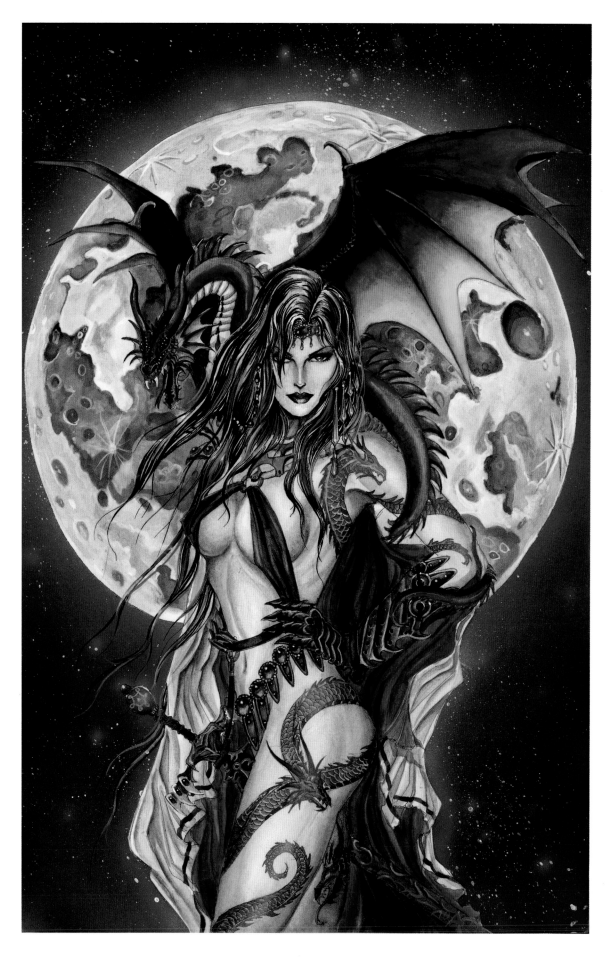

Dragon Witch #1: Dragon Moon

Dragon Moon was the prototype for the *Dragon Witch* series, and the figure is still one of the most popular of my images. The dragon witches are pure pin-up. I really hadn't explored that direction in my art before. I really admire the work of Olivia and Vargas, and this series is an homage to them.

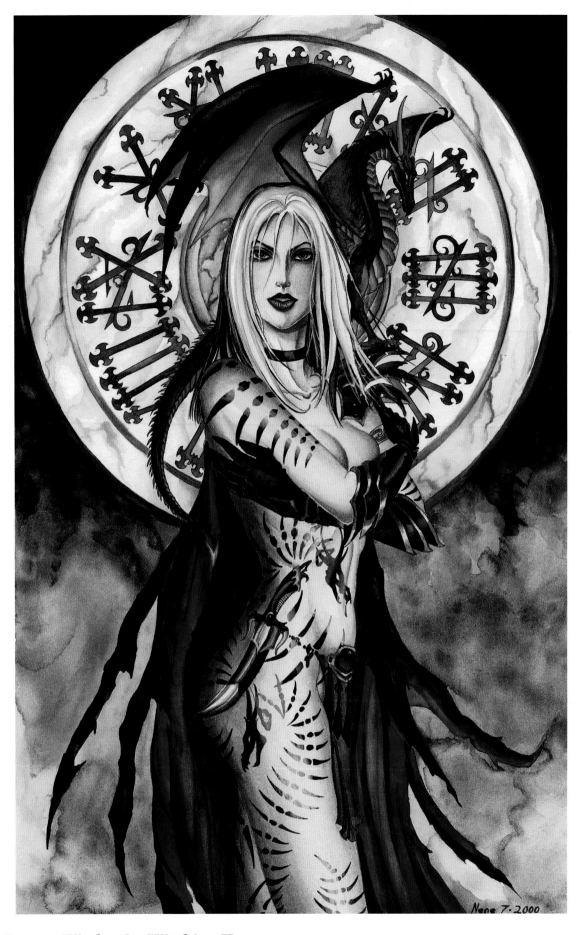

Nene 7·2000

Dragon Witch #2: Witching Hour
The clock in the background is missing a key feature:

It doesn't have hands. Midnight is the witching hour, but no matter how I tried to paint the hands, they looked like big spikes growing out of the top of the figure's head, and I couldn't fashion a digital clocks, for it just wouldn't have that gothic feel.

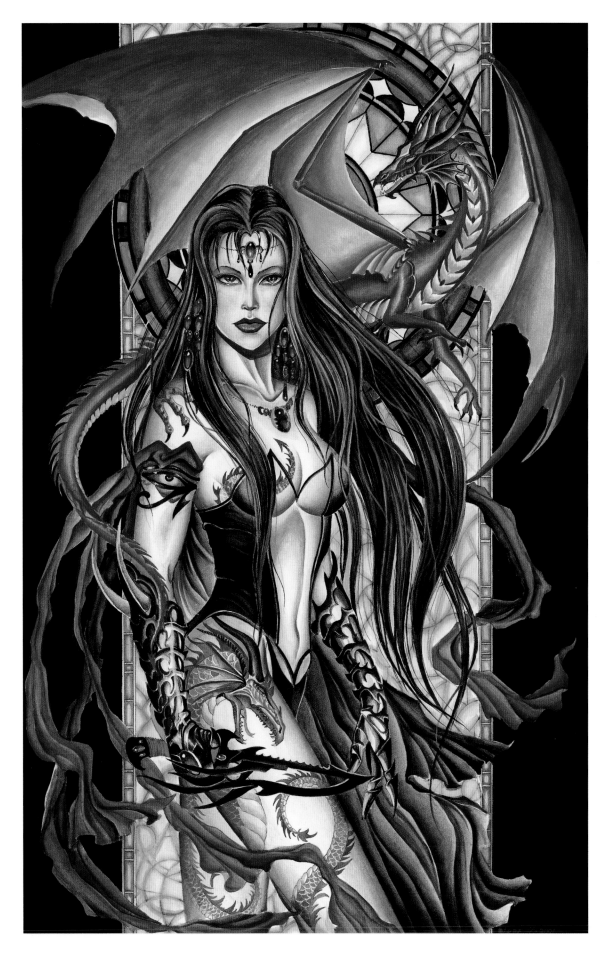

Dragon Witch #3: Corona

Corona is the third in the *Dragon Witch* series and is designed to stand beside *Halo*, the fourth in the series. The arm band that the figure is wearing is a solar eye, taken from Egyptian imagery.

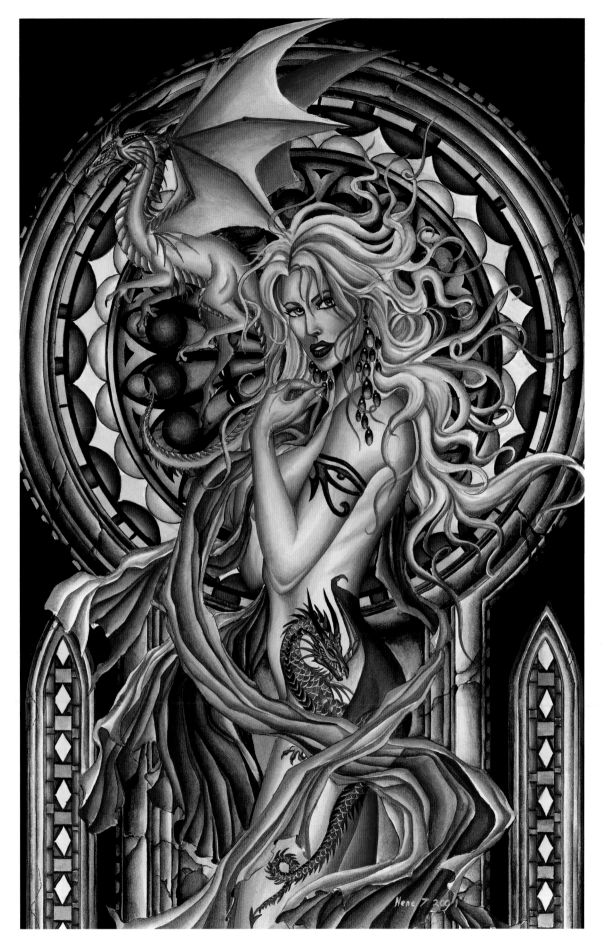

Dragon Witch #4: Halo

Halo is another Dragon Witch painting, but I moved away from the warrior motif when I was making it. I wanted the woman to be a little more vulnerable. *Halo* is the only figure in the series that doesn't carry a weapon.

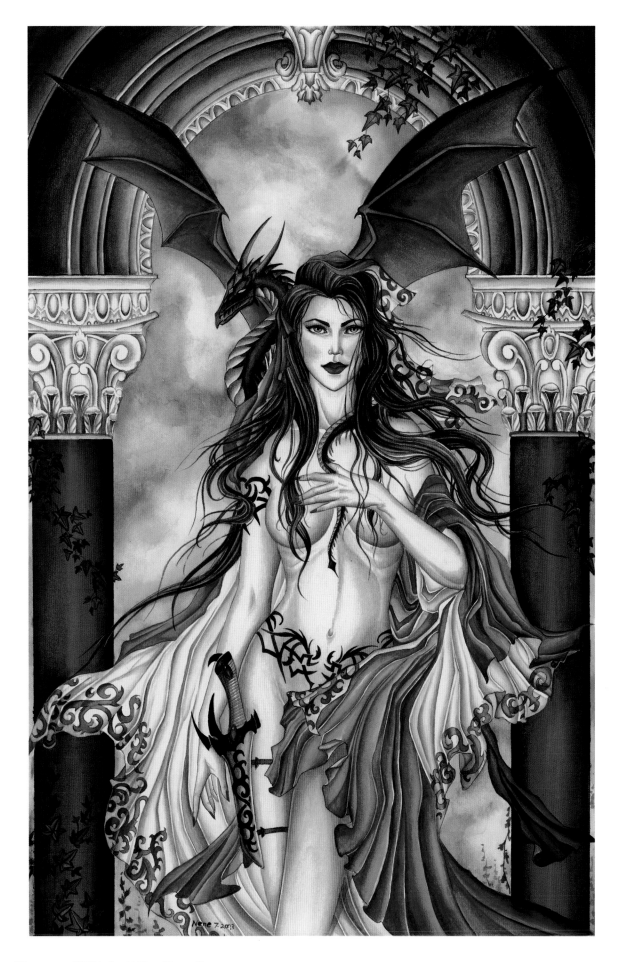

Dragon Witch #5: Oracle

Oracle is a very direct piece. And while the figure is practically naked, she doesn't exactly look vulnerable. The large knife may help to give her an air of boldness, but I think it has more to do with her direct gaze and confident stance.

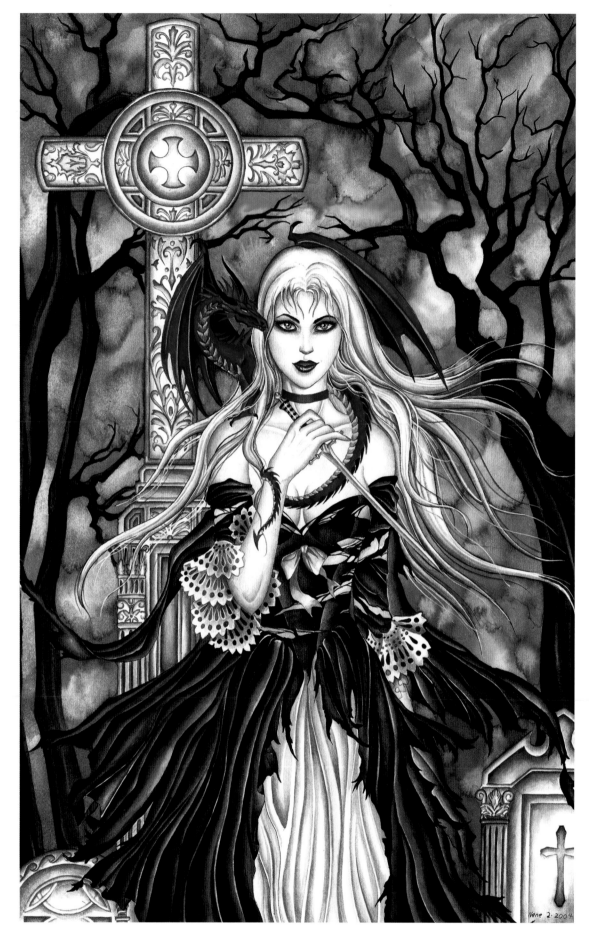

Dragon Witch #6: La Victime

I love French History! After the French Revolution and the Reign of Terror, people that had lost relatives to the guillotine would throw lavish parties at which they wore red ribbons around their necks to signify their loss. It became the cool thing to do: if you weren't a victim, then you weren't allowed to attend the parties.

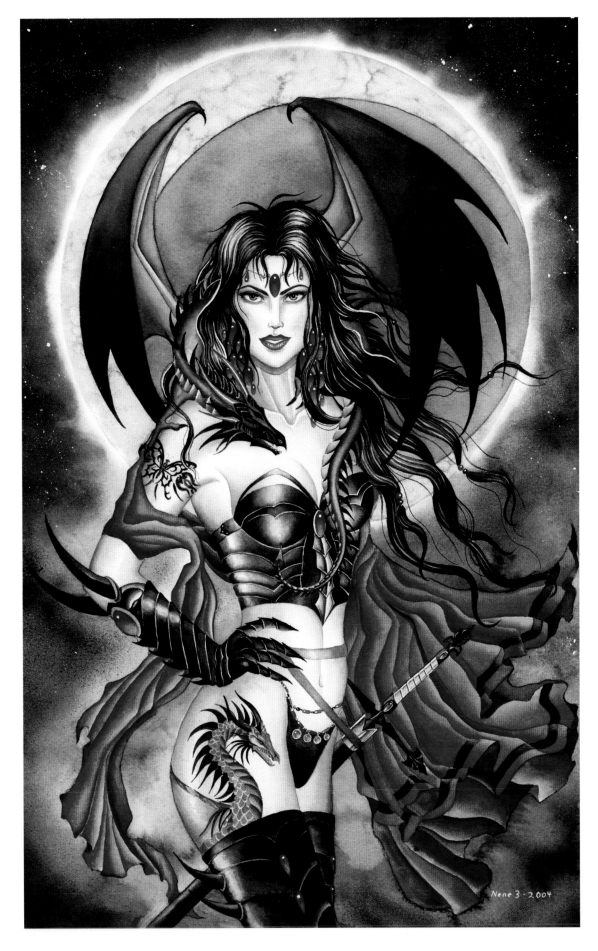

Dragon Witch #7: Guardian

Guardian is the quintessential Dragon Witch: scantily clad, armed to the teeth, and tattooed. While *La Victime* has a gothic feel, *Guardian* is pure, unadulterated fantasy.

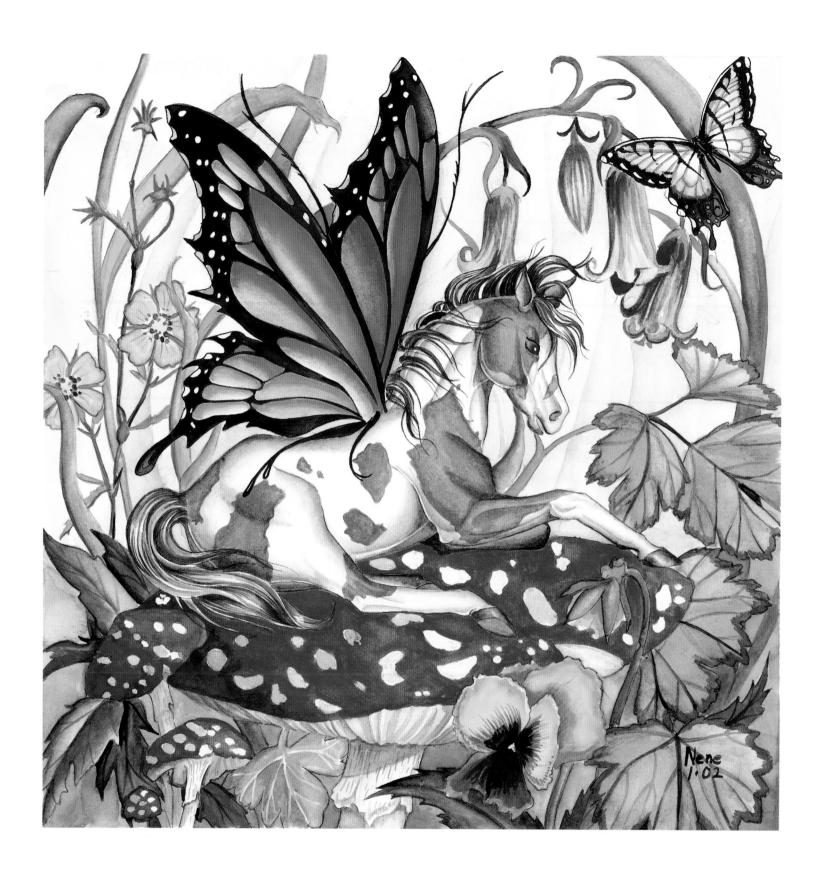

Faery Foal

This piece is just about as cute as it can be, rivaling *Candy Cane* for pure saccharin sweetness. I love horses, but this was the first time that I had ever painted a foal. I think it came out pretty well!

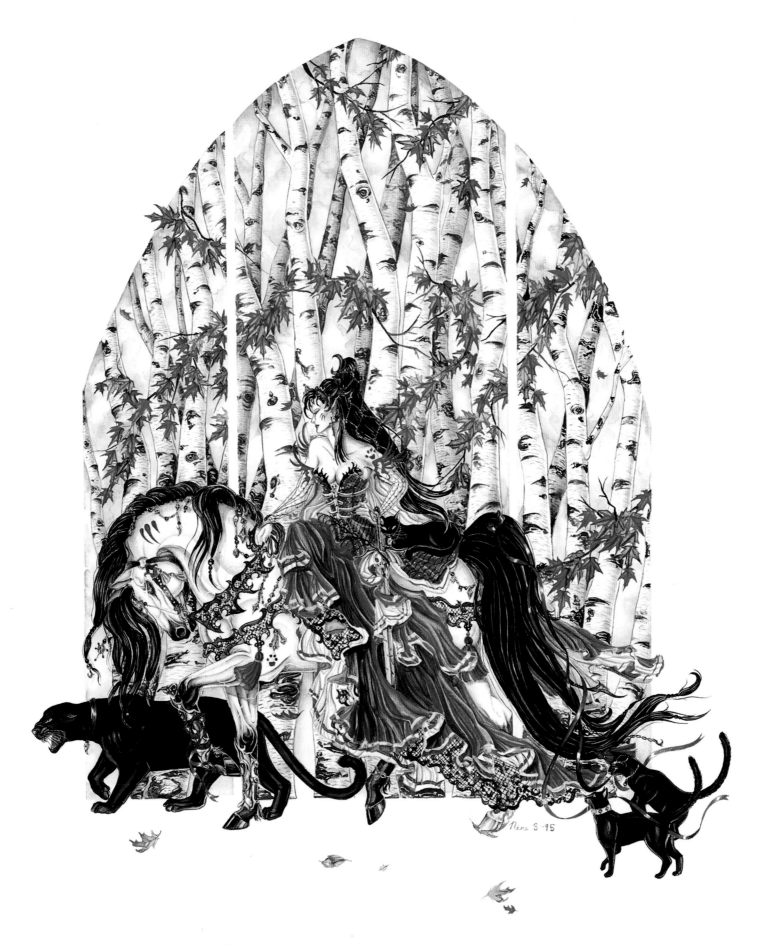

Faery of Black Cats

Knight of Winter and *Faery of Black Cats* marked the first real growth of my art. Before I painted them, I had been working almost exclusively on Collectible Card Game art for several different companies. At that time everything that I painted was a commission, but I painted *Faery of Black* for myself. Once I completed it, I knew that I had to become my own boss and paint only the things that I wanted to.

43

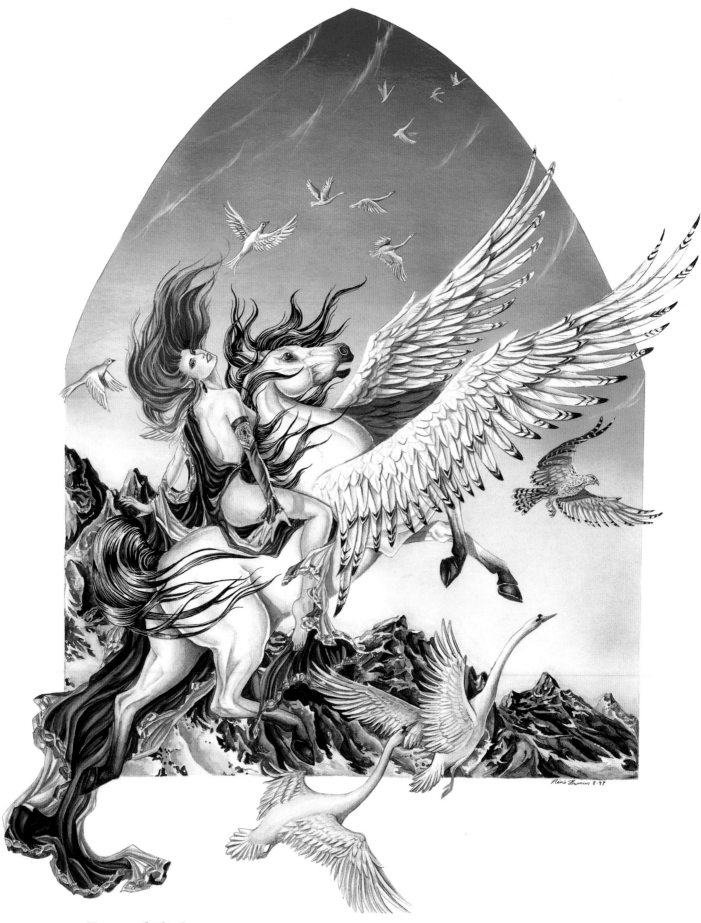

Faery of Flight

Faery of Flight is the third print in the Faery series, and one of the first pieces in which I attempted to paint mountains. The blue sky was also a departure. I normally paint skies using Payne's gray washes to create a mist-like effect.

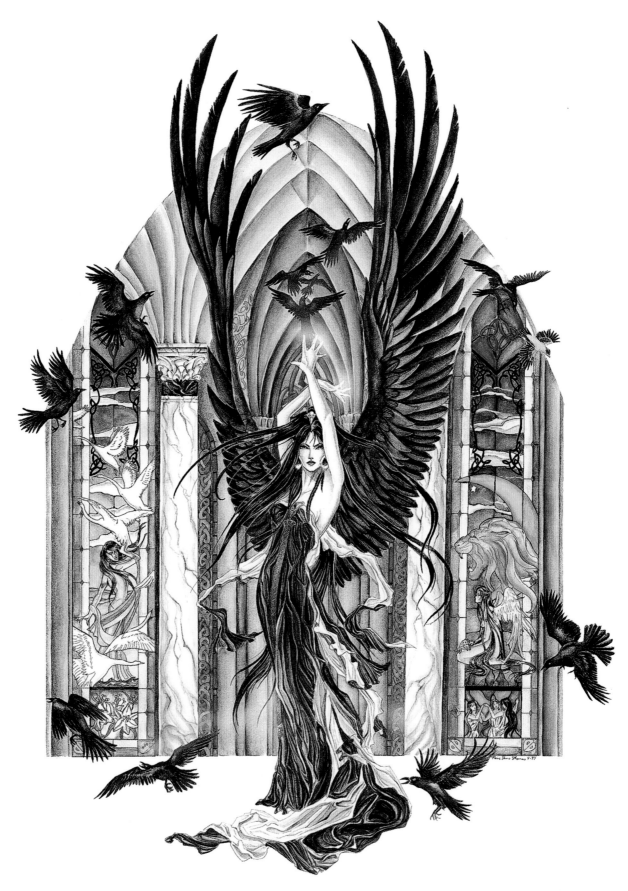

Faery of Ravens

Faery of Ravens is one of my most popular pieces. Normally I don't mess with symbolism, preferring instead to leave interpretation to the viewer, but I added quite a bit to this piece. The faery is actually creating the ravens, and the picture has 12 ravens flying in a counter-clockwise circle, with the thirteenth bird having actually been created as a goldfinch by mistake. The idea here is that magic is never predictable, and that sometime things can go awry. If you look carefully, you'll see that the stained glass windows tell their own stories as well.

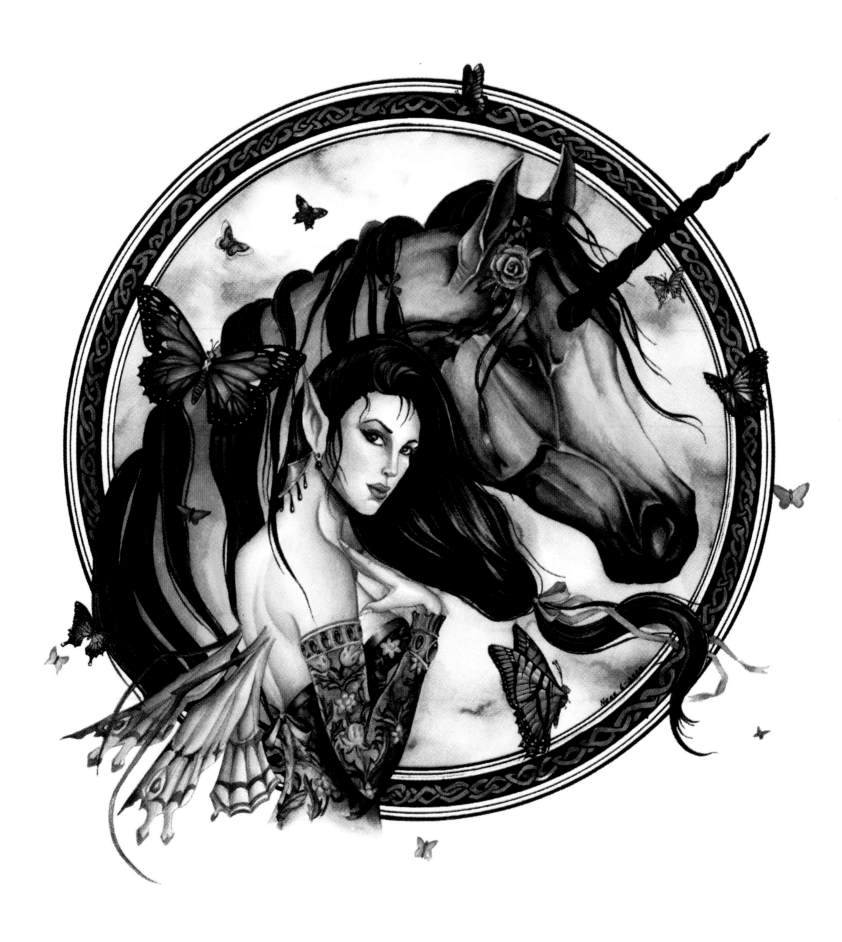

Faery Princess

Designed as a set with Le Fay, Faery Princess is a young, demure faery compared to the older and more seductive Le Fay. Even though she is supposed to be demure, the expression on her face is very sexy…sort of a come hither look.

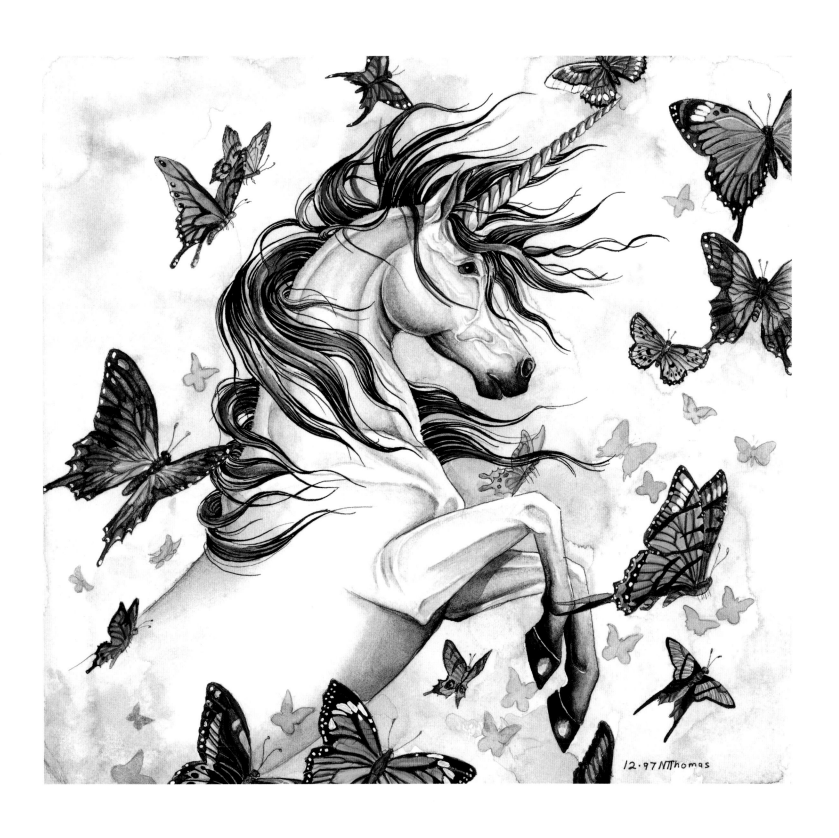

Faery Ring

This picture marks the beginning of my love for butterflies. Unlike the two Butterfly Ring images, this picture shows butterflies in flight, and not just pinned to a board. I am very happy with the way the unicorn came out as well. The shading on the horn and the shadowing on the horse came out better than I'd hoped.

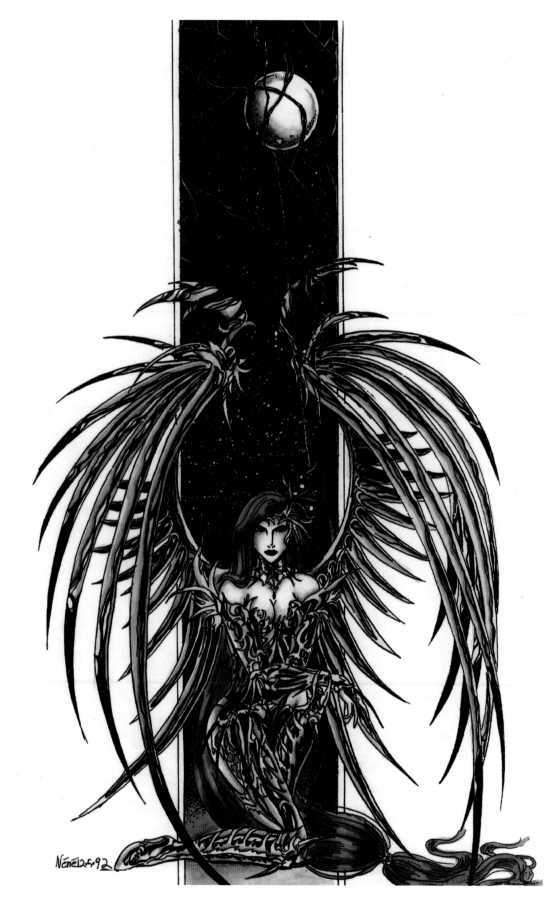

Fall

Before I became a professional artist, I tested the waters by releasing a few hand-colored prints. My earliest works were small editions shown at local conventions, and several of them bore striking resemblances to the anime fan art that I started with. This is Chesare, the same character featured in *Birds of Prey*, *Memento*, and *Absinthe*. As you can see, the character design has changed somewhat over the past decade.

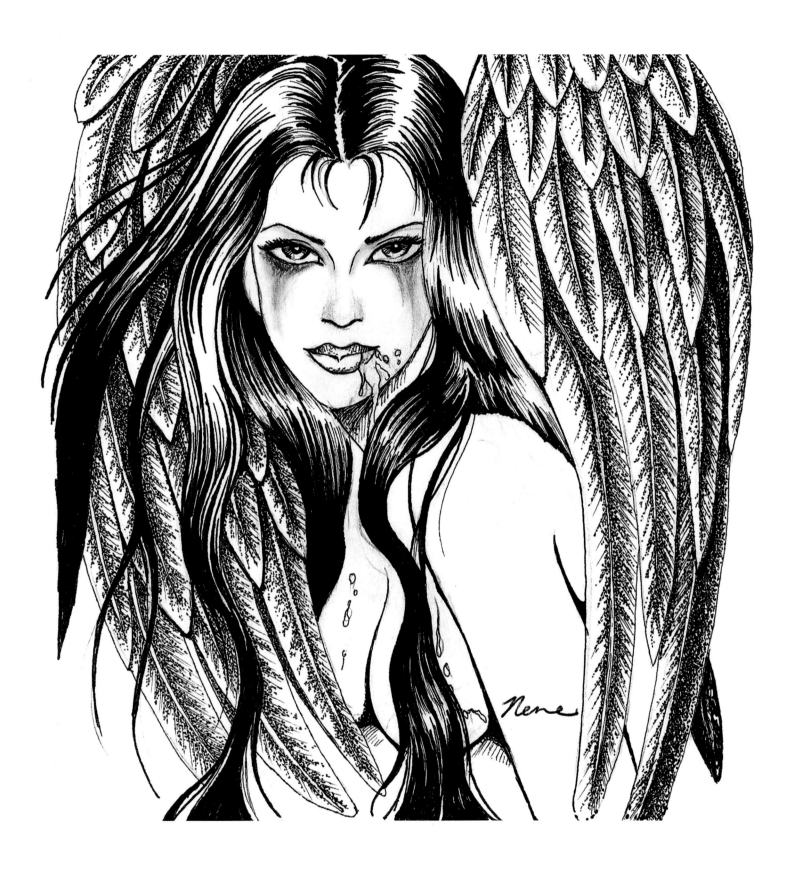

Fallen Angel

Fallen Angel was the prototype for *Blood Angel*, and as you can see, it is a lot darker. After I painted *Blood Angel*, I had to decide if I wanted to take one extra step further and put dark eye shadow and blood on her face. Ultimately, I decided against it, the changes wouldn't have added all that much to the overall effect. So I left it the way it way it was, and renamed it *Blood Angel*.

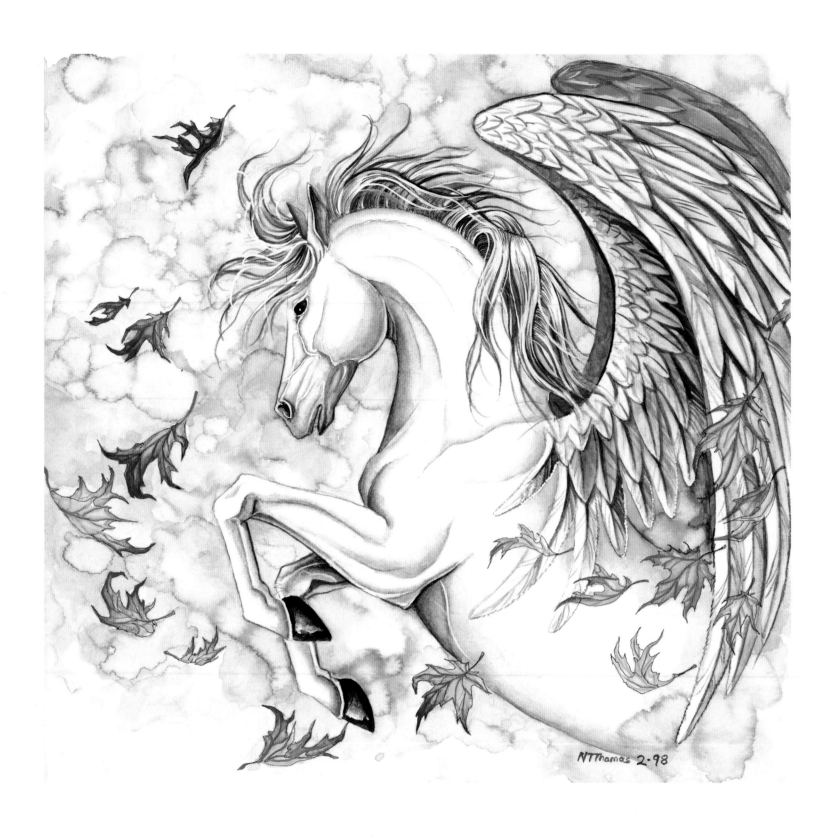

Fire Dance

Fire Dance is the companion to *Faery Ring*, and is a stereotypical Pegasus. The thing I like best about this picture is the flow of the leaves. They look as if a sudden wind has lifted them up and swept them aside. Autumn leaves are stunningly beautiful and, next to birch trees, are my absolute favorite things to paint. In fact, since I think birch trees have ugly leaves, I often paint oak or maple leaves on them, instead of their real leaves.

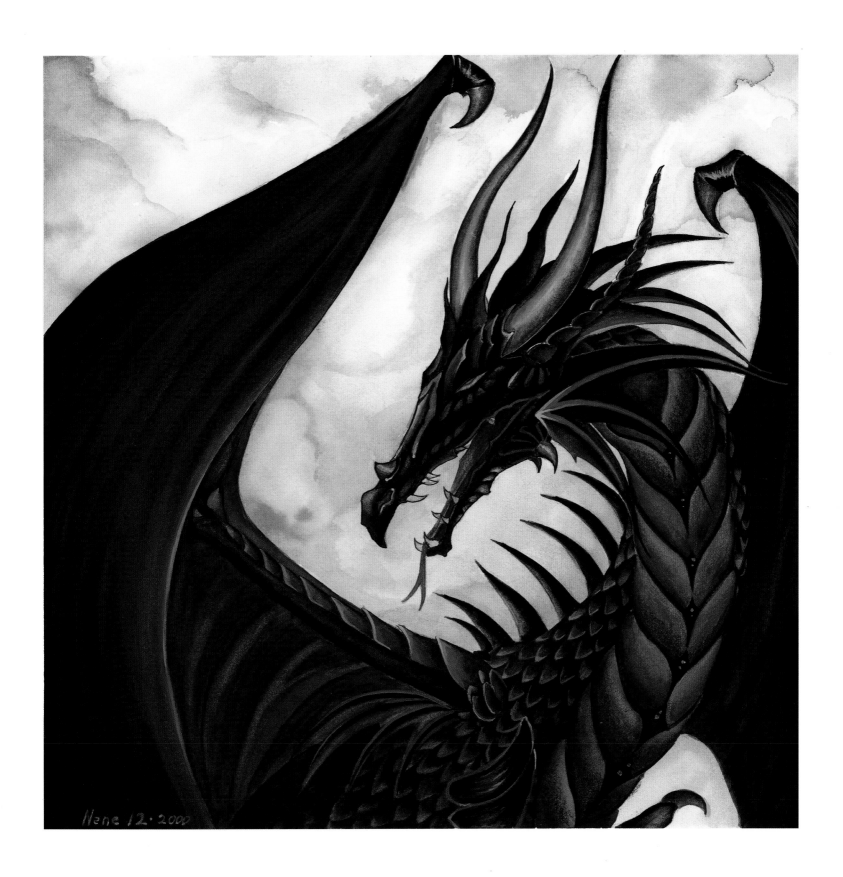

Fireheart

In the world of Dungeons and Dragons, good dragons are signified by precious metals, and evil dragons are signified by colors. Therefore, black dragons are evil, while gold dragons are good. *Fireheart* and *Sundancer* are a set, one evil, one good, but I like black dragons better. They just look cool!

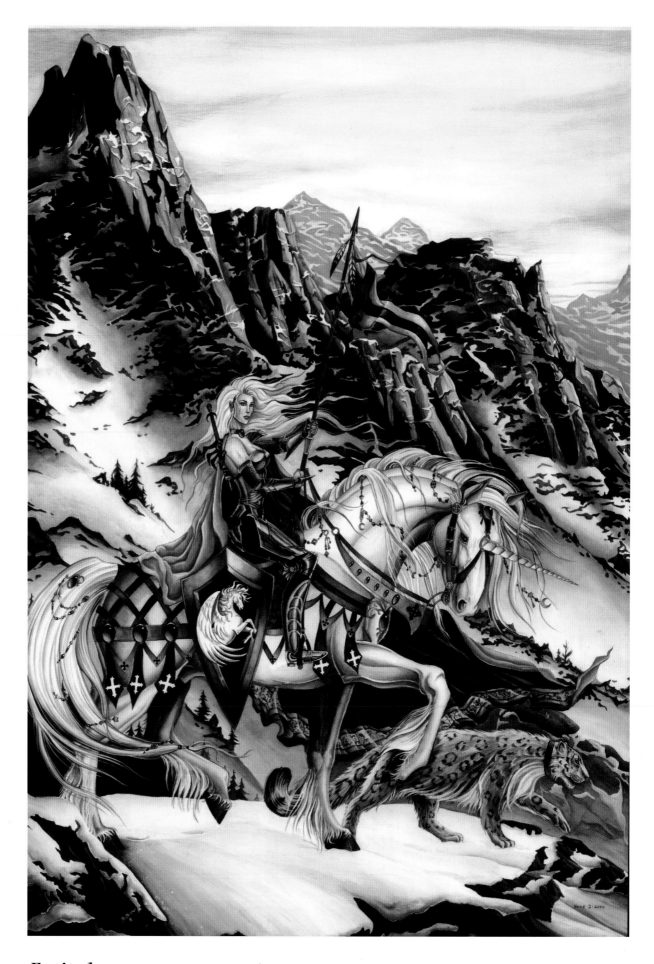

Fortitude

The original name for this image was *Bradamante*, but I really got tired of answering the question, "Who is Bradamante?" So I renamed it. Bradamante, by the way, was the niece of King Charlemagne, the legendary French ruler. She was a female paladin and an exceptional warrior. She eventually married a Saracen warrior named Rogero, but only after, she forced him to convert to Christianity.

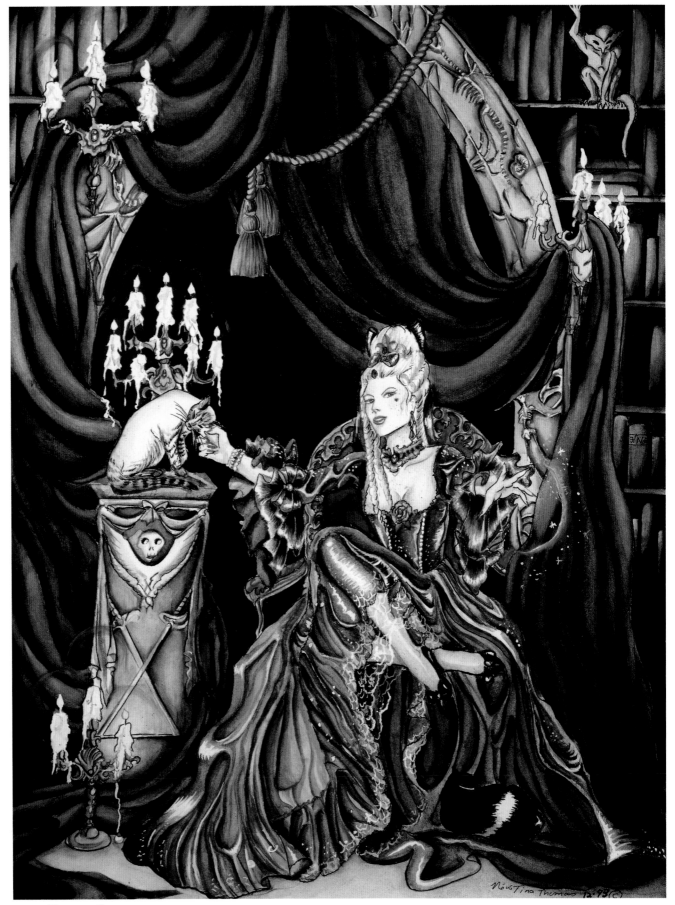

Greensleeves

Greensleeves holds the distinction of being the oldest true painting in this book. I painted this one in 1993, five months before *Knight of Winter*. My style was just starting to take shape, and for all of its relative crudity, this piece contains many elements that I still use today. After all, some things never change, such as my love of elaborate dresses and elegant hair styles. On a personal note, the cats featured in this picture are named Nirvana and Cowser, and they belong to two of my dearest friends, Beth and Sue. Sadly, Cowser has since passed away.

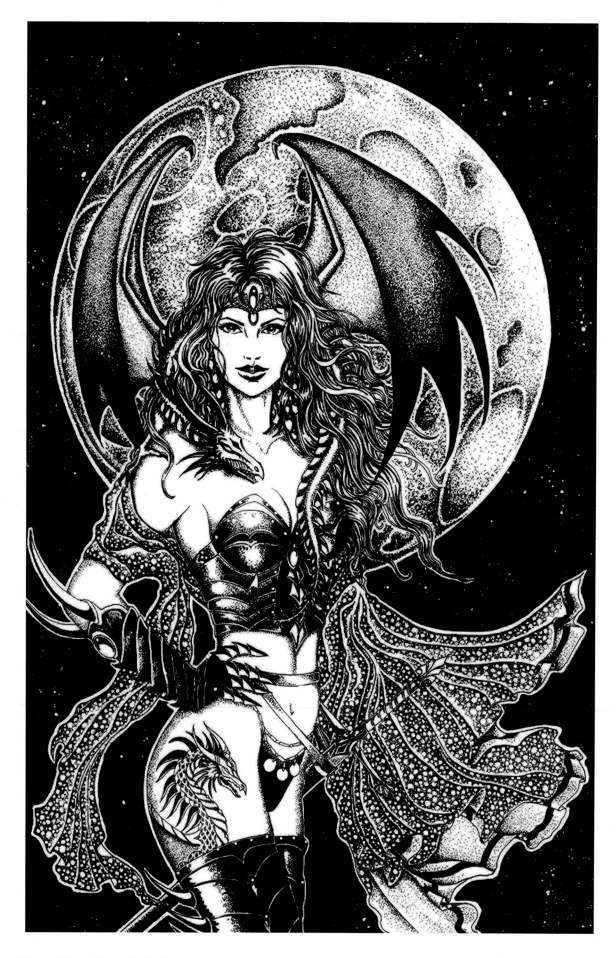

Guardian Pen & Ink

Guardian belongs to the *Dragon Witch* series, which can be seen in its completed form in this book. Ann-Juliette did the ink work, and really made this piece stand out. In particular, the pointillism work she did on the moon and the dragon's wings really make the image pop out, and that isn't easy to achieve in black and white.

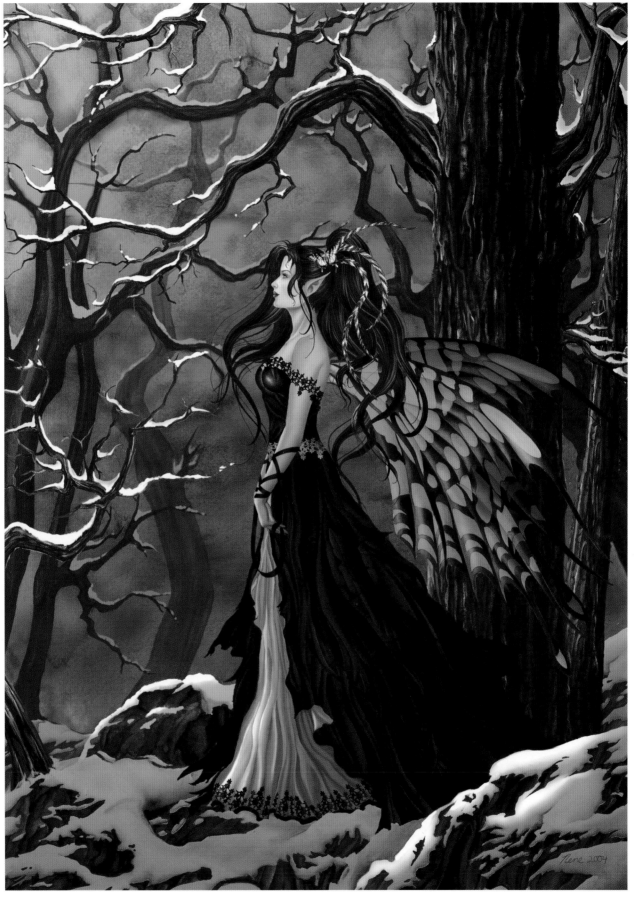

Hope

Every now and then, an artist can actually see the improvement in his or her work. Generally speaking, improvements in technique are very gradual, and usually you don't even realize that you are getting better. *Hope* is the beginning of the new direction that my art is taking, and I couldn't be more pleased with it. When I finished painting it, I couldn't believe how well it came out or that I was the one who painted it! When you create a piece like this, it re-energizes you because you want to repeat your achievement again and again.

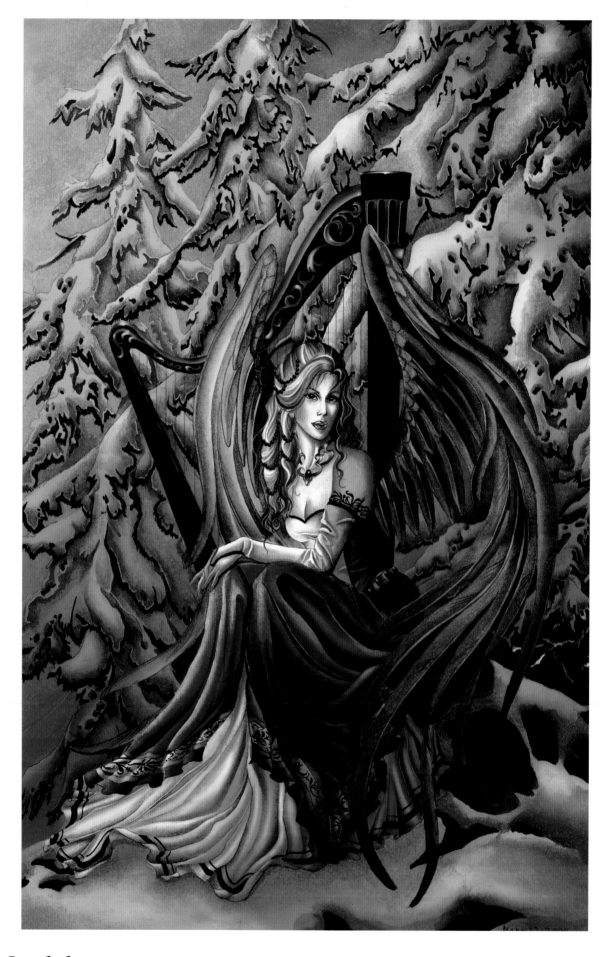

Interlude

This piece was completely inspired by my sister, Ann-Juliette. While Angie is developing into a very good artist, she is also a very accomplished musician. Her instrument of choice is the harp, and she plays it beautifully. The harp is an elegant instrument, and I felt it would fit perfectly in a painting.

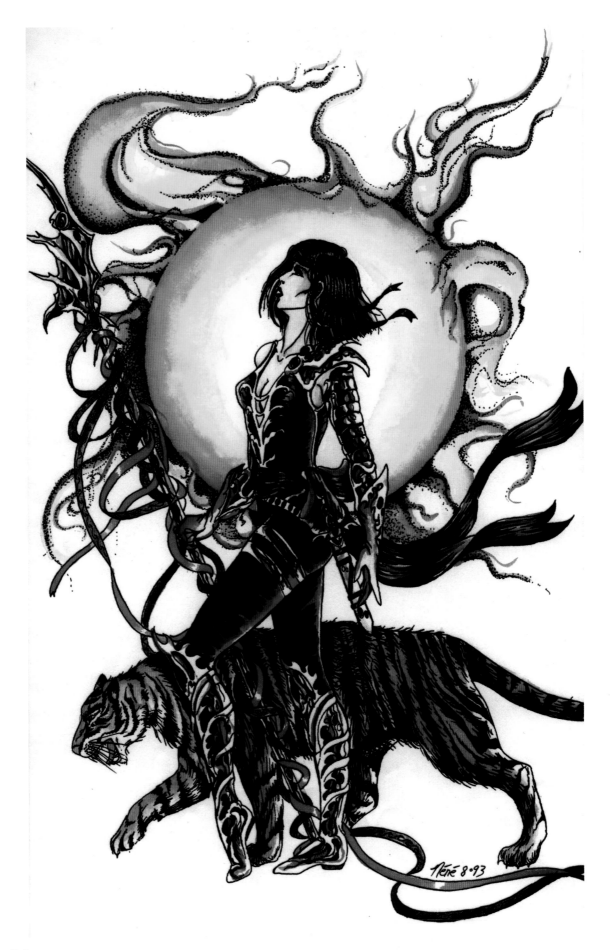

Iris

Iris is a hand-colored print that I did very early in my career. The sun in the background does a good job of focusing your eye on the center of the piece. In fact, the effect is so successful that I used it in the *Dragon Witch* series: each print in that series features a round object of one type or another in the background.

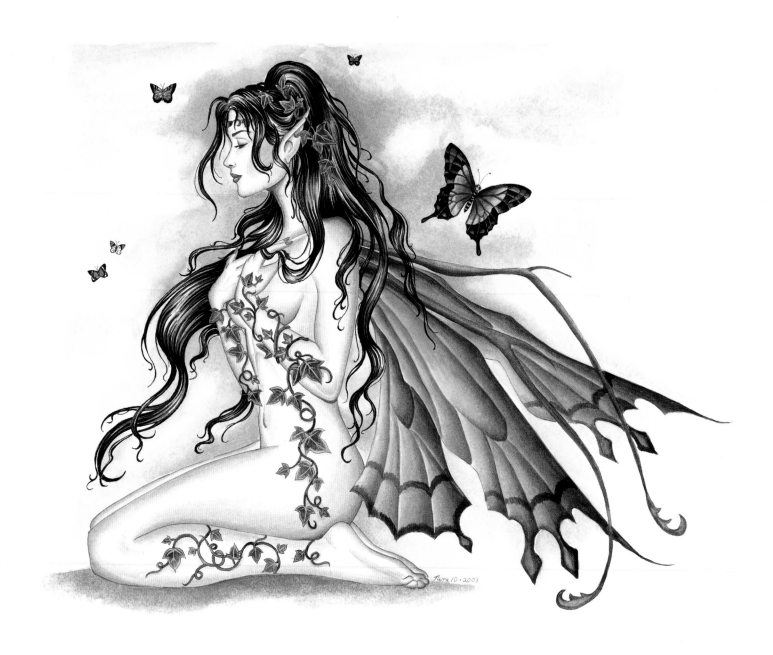

Ivy

My artwork conforms to a certain number of self-imposed rules. The first of which is that I never paint true nudes. So if you look closely at any of my paintings, you will see that while I may hint at nudity, I never show it. *Ivy* is no exception.

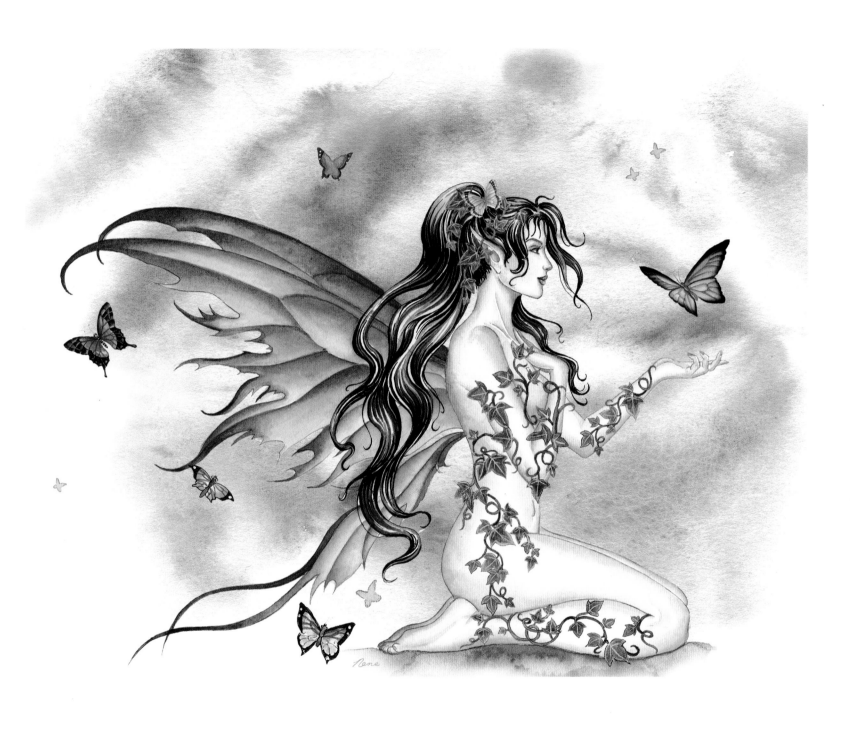

Ivy 2: Vines

Ivy 2 was commissioned by the same company that asked for a second version of *Arachne*. They want-
ed me to capture the same feel as I captured in Ivy, but make it different enough to be noticeable.
Normally, this wouldn't be a problem, for I can usually just change the way a figures clothes look, but
with *Ivy*, that wasn't an option.

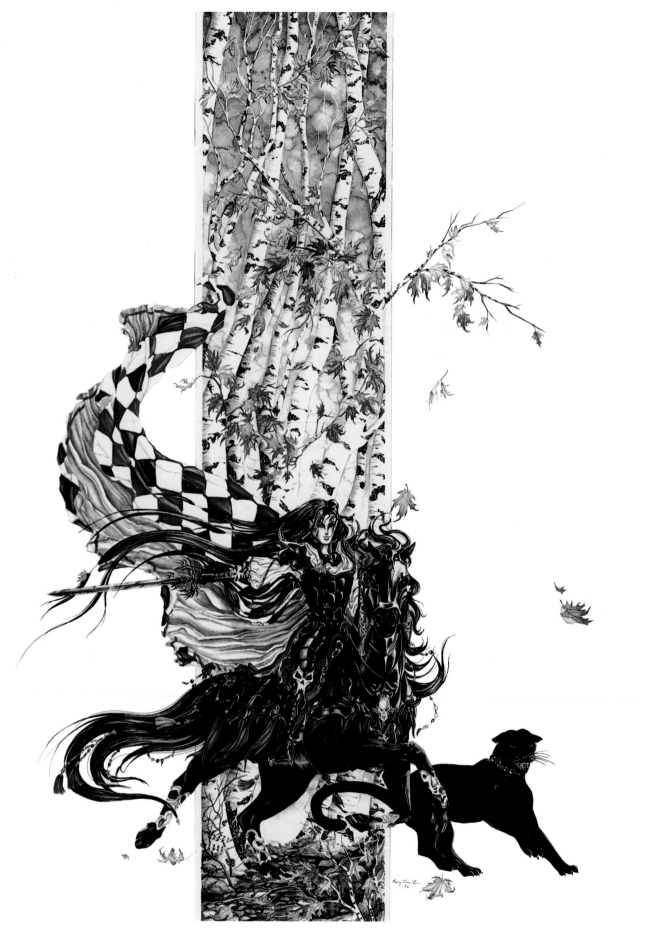

Knight of Fall

This painting was a companion to *Knight of Winter and* was intended to be the second of four paintings in a seasonal series. Unfortunately, I lost my nerve and decided not to finish the series. At the time I was very confident with winter and fall scenes but had never attempted a spring or summer scene.

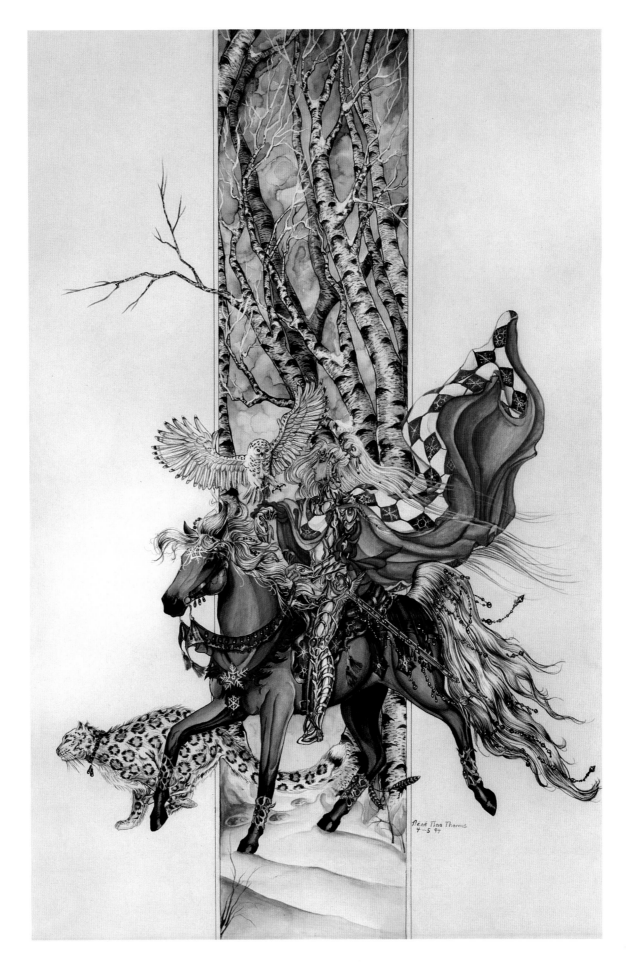

Knight of Winter

In a very real sense, this is the piece that started it all. *Knight of Winter* holds the distinction of being the first professional quality painting that I painted for myself. The success of this piece convinced me that I could make a living outside of contract art. Shortly after I finished it, I left that world and went into business for myself.

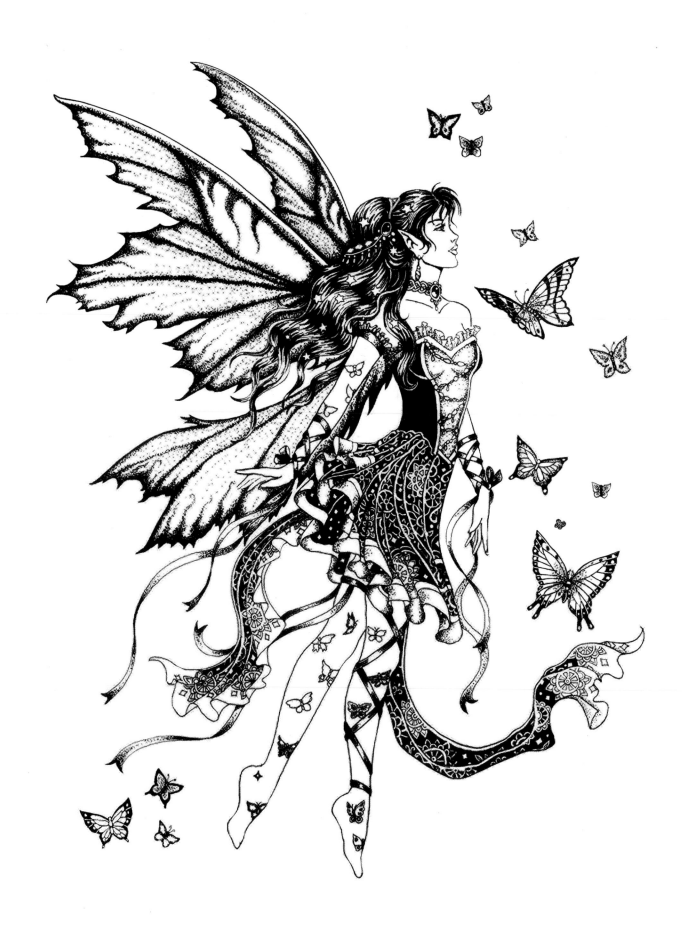

Lavender Serenade Pen & Ink

When I first designed the *Orchestral* series, I had no idea just how popular it would become. I feel that the designs of the images in that series are very simplistic. But I think the simplicity adds to their charm, and although the individual images will never attain the status that *Wisdom* has, they are nonetheless very well regarded.

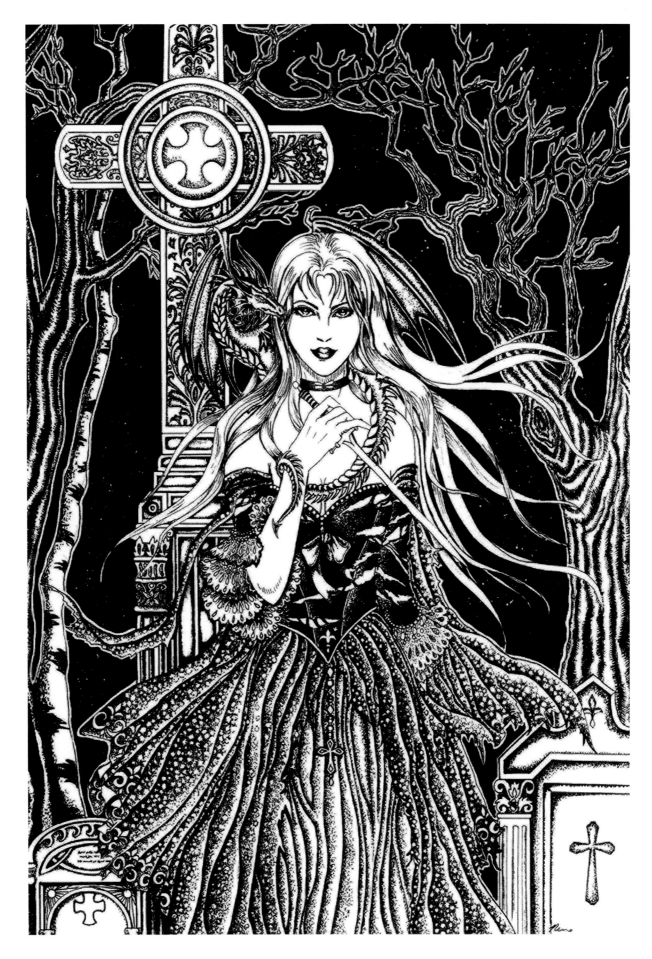

La Victime Pen & Ink

La Victime is part of the *Dragon Witch* series and can be seen in its completed form in this book. I had always envisioned *La Victime* as being a dark piece, but a lot of the elements that I had used on *La Victime* couldn't be translated into a black-and-white image. For example, there could be no dead grey skin in a black and white image.

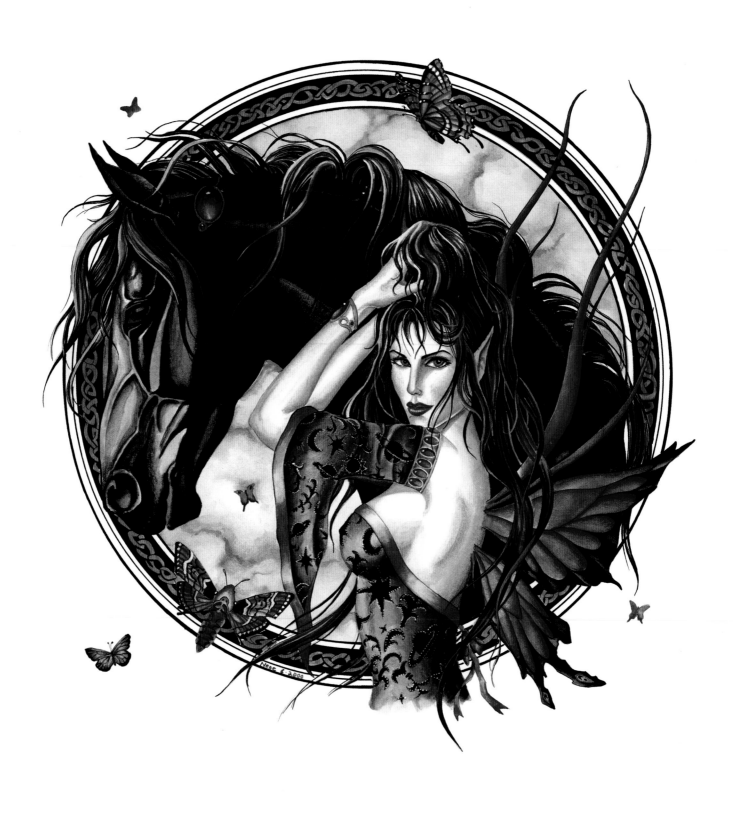

Le Fay

While the faery in *Faery Princess* had an innocent come-hither look, *Le Fay* has eschewed subtlety and is instead giving us a come-and-get-it-big-boy cheesecake pose. I guess the older you get, the harder it becomes to play the ingénue!

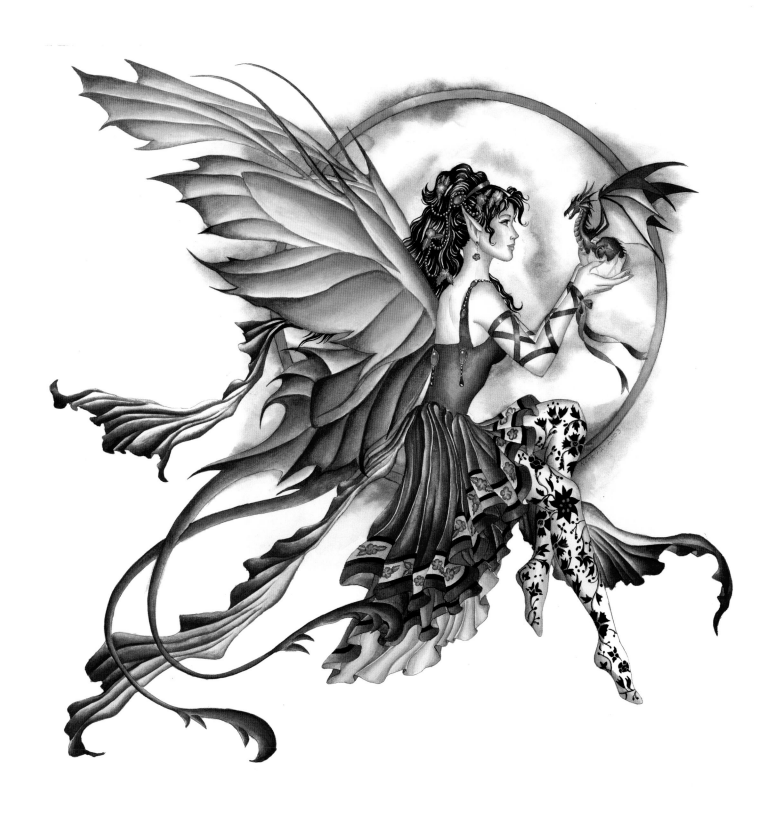

Little Dragon

Little Dragon and *The Gift* were painted around the same time as the *Orchestrals*. I really wanted to work on simpler pieces, and I didn't want to spend a lot of time on any one piece. *Little Dragon* marked the end of my striving for simplicity, and after I finished it, I decided to start working on more elaborate pieces again.

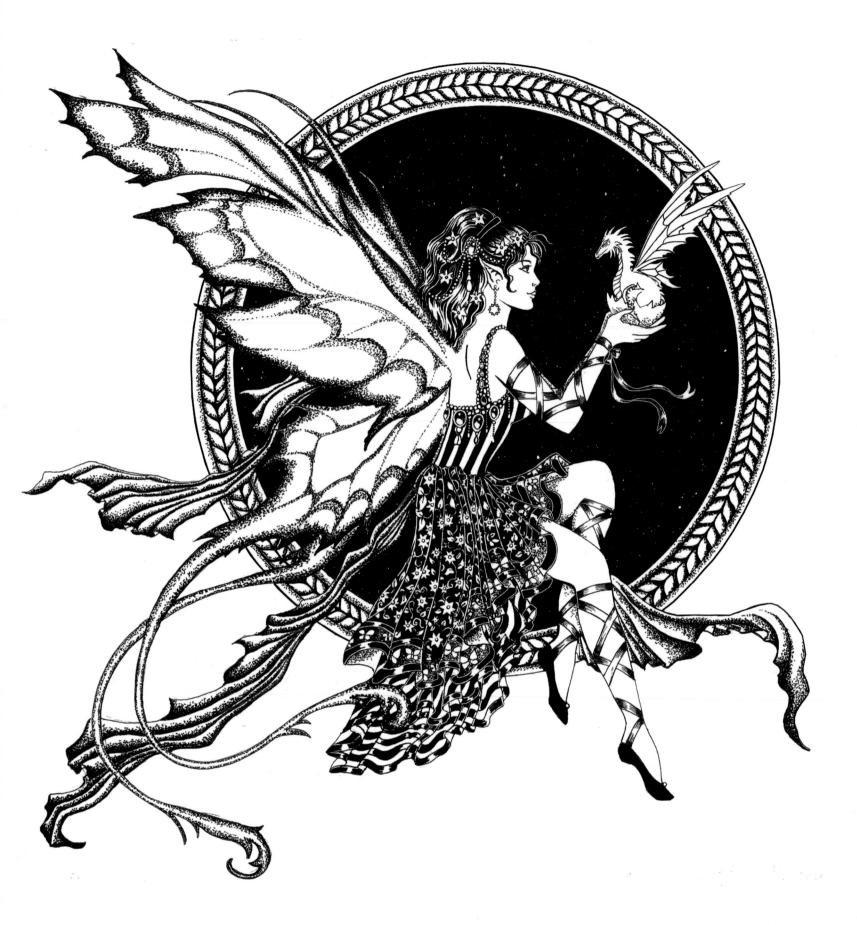

Little Dragon Pen & Ink

Pen-and ink pieces like this one are very challenging to complete, for the simplicity of their design makes it difficult to turn the sketches into worthwhile pen-and-ink. For the *Little Dragon Pen and Ink*, Ann-Juliette added all of the patterning that you can see on the dress herself. Such patterning has become a staple for all of her designs. While I like dresses to be plain with an elaborate fringe or lace trim, she like her dresses to have elaborate patterns. You can see that preference very well in this piece.

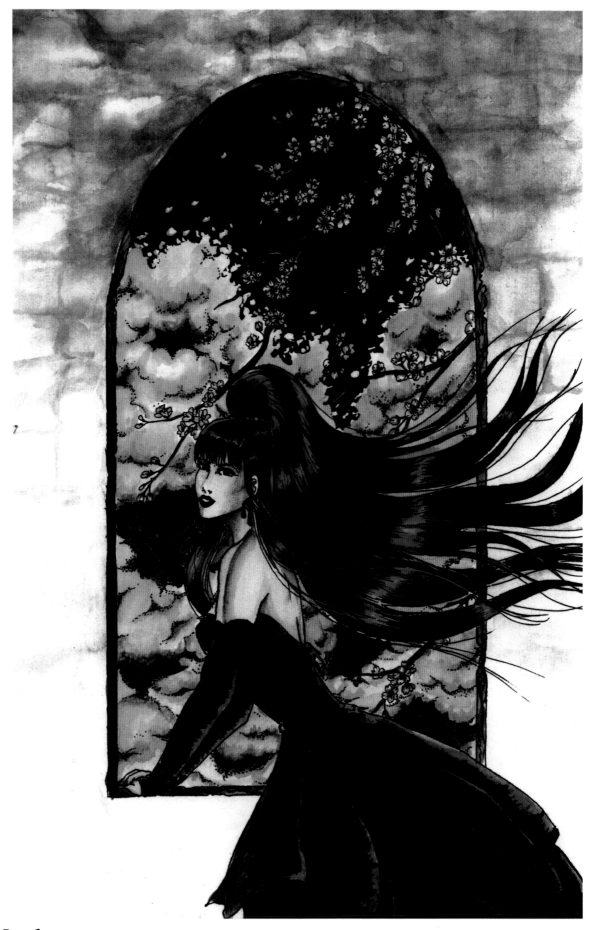

Lyrahe

Lyrahe is another character portrait from the story that I've been working on. She is the older sister of Chesare and was briefly the lover of Valeriad. On a personal note, I really love cherry blossoms. Visually, cherry blossoms are almost as good as birch trees. Unfortunately, it is very difficult to work a pink background into the dark paintings that I tend to prefer, so I haven't used them in a very long time.

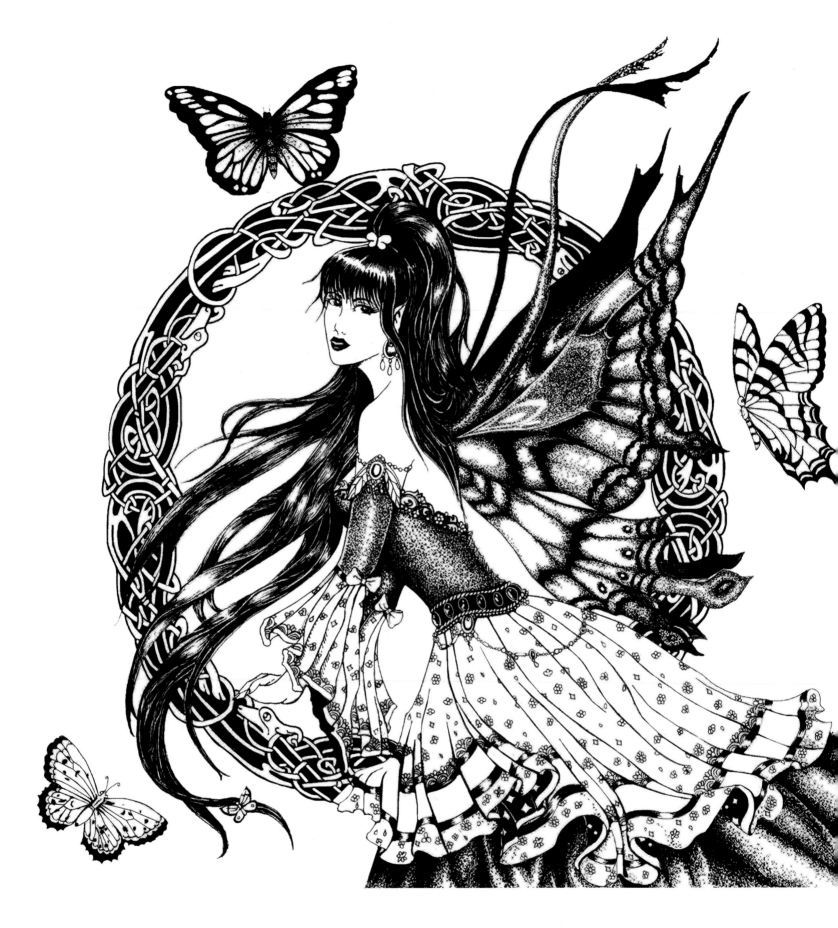

Lyrahe Fae Pen & Ink

Of all of the pen and ink originals that Ann-Juliette has made from my work, this one is the oldest image she's used so far. The design was simple enough to allow her to the freedom to use her imagination, yet elegant enough to make it appealing. The finished product is so good that even I can't tell that it was created from an older image.

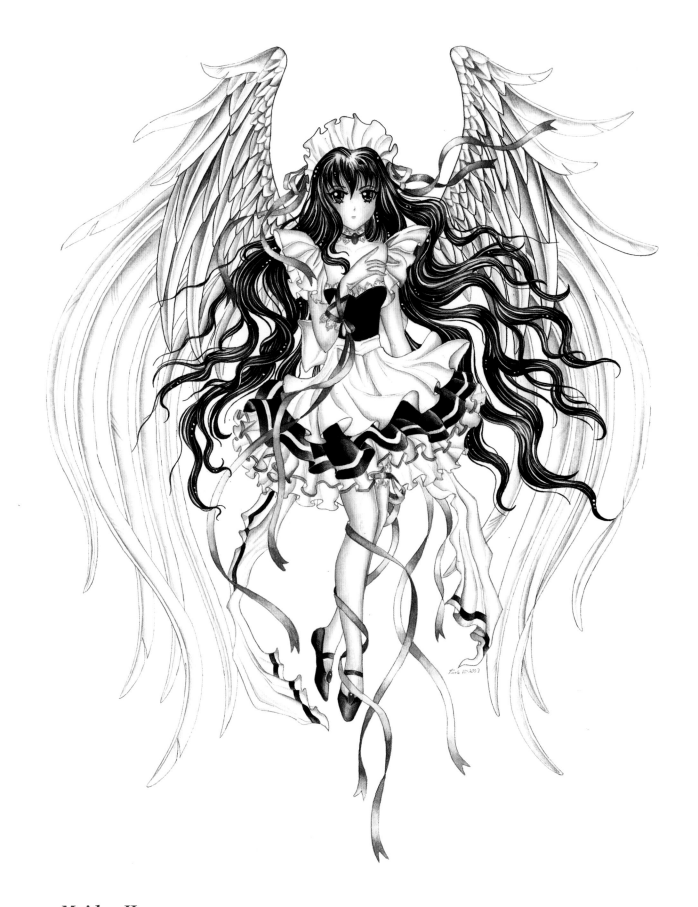

Maiden Heaven
In Japan, frilly maid costumes on anime characters are a really popular theme. When I saw a book filled with picture after picture of incredibly cute maids, I knew I had to do one, just to see if I could!

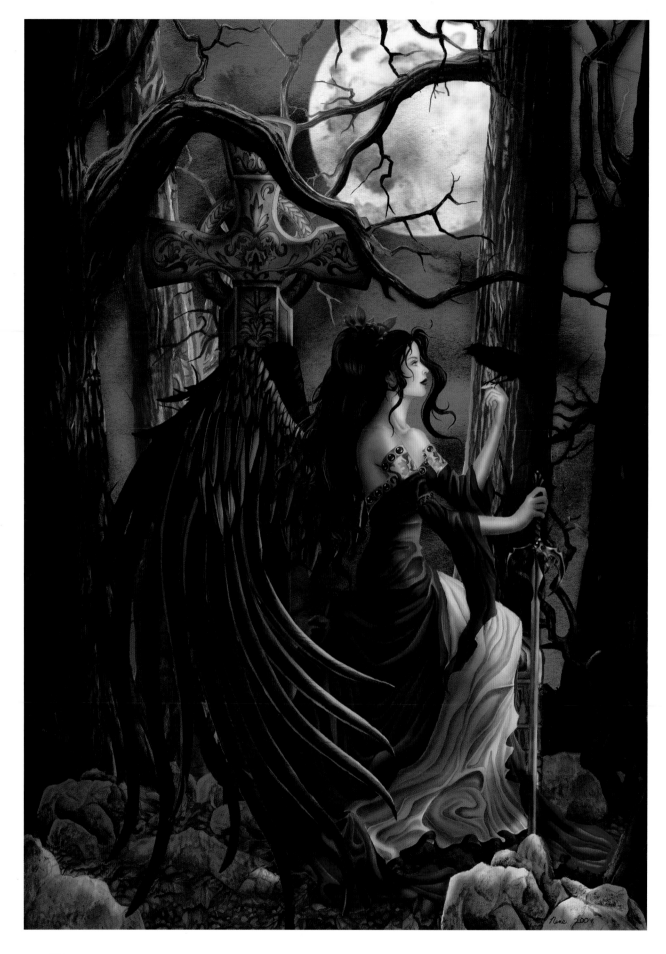

Memento

When I envisioned this piece, I pictured the woman with black wings, sitting in front of a tombstone. After I finished it, I decided that it was really too dark, so I did a second version that eventually became *Always*. While the women in both pieces are exactly the same, the difference between them is as clear as the difference between night and day.

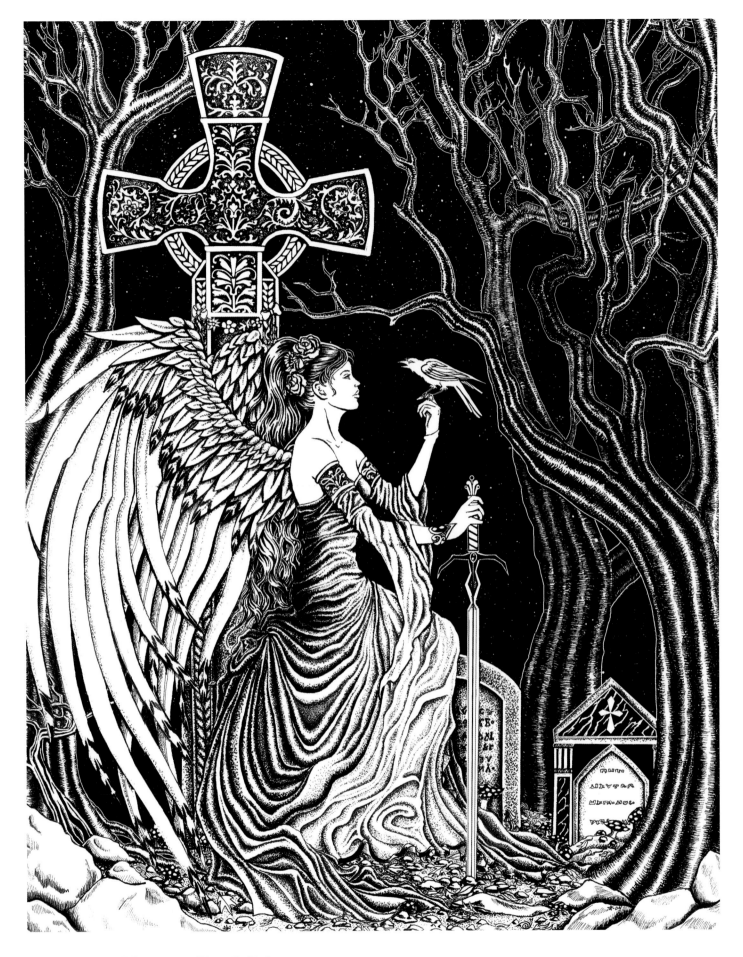

Memento Pen & Ink

While the detail work on this pen and ink is superb, I think the piece loses a little of its power without the color. That seems strange to me. Color, I feel, actually softens a dark piece, but in this case, color has the opposite effect. I do like one aspect of this image though: the gravestones.

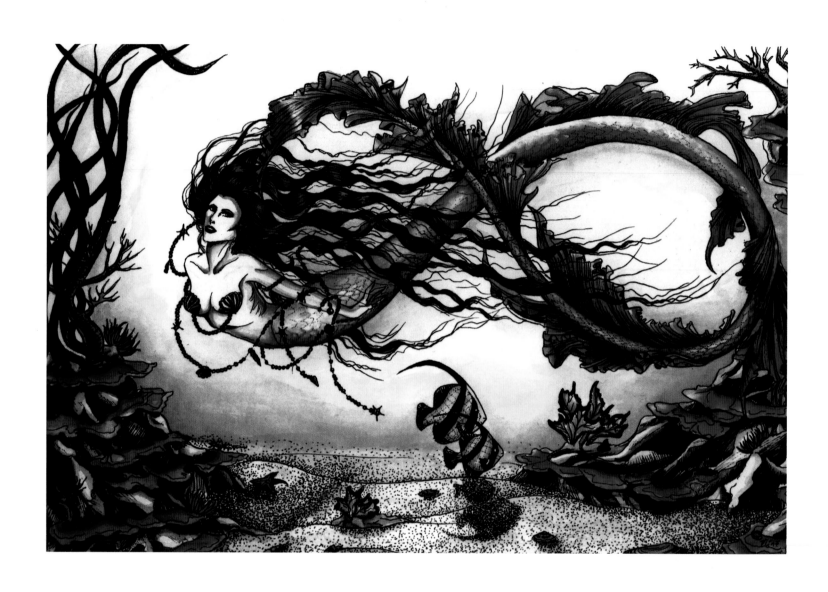

Mermaid

No matter what my subject is, I almost always prefer to use intricate, elaborate designs instead of simple ones. When I painted *Mermaid*, I wanted her to have a soft flow, with tendrils of hair that resembled a kelp forest. If you paint hair correctly, it can often tell just as much of a story as a good expression. This image was hand-colored print that I did early in my career, but it heavily influenced *Aquamarine*, a mermaid I painted years later.

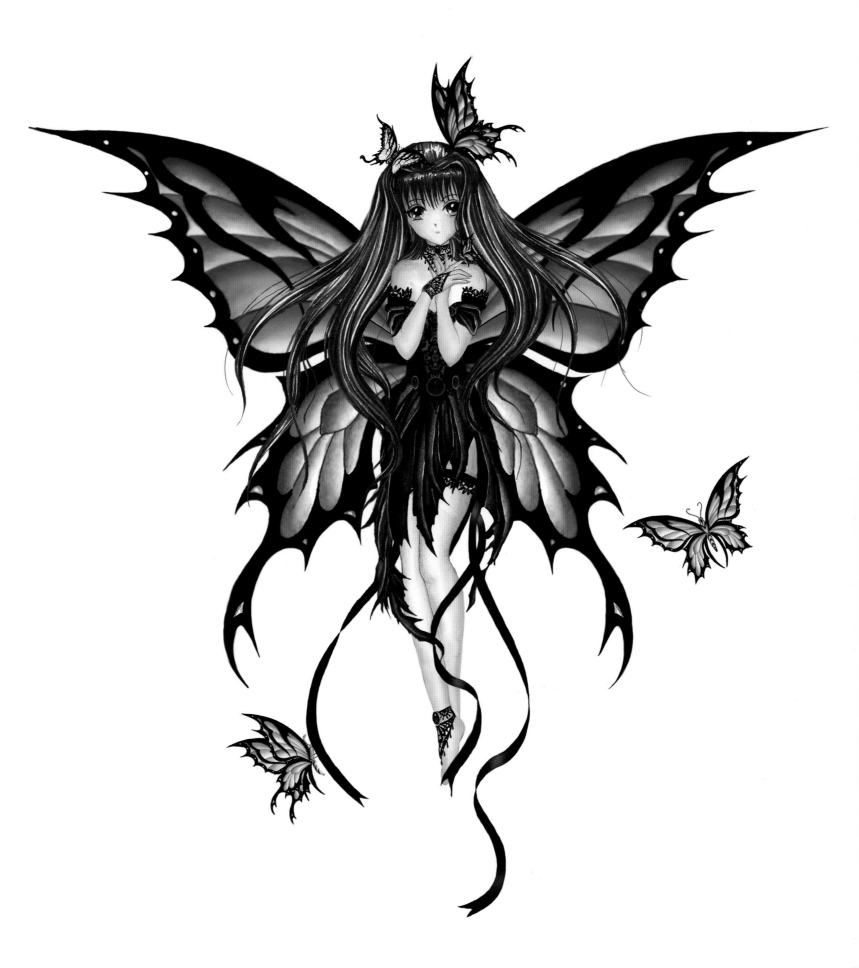

Midnight Blue

I decided to try something a little different on this piece. While *Midnight Blue* is still an anime faery, I made the faery a little less frilly and a little more edgy. She's still really cute, though! Traditionally, the hair color on anime characters is very colorful, with shades and hues that have nothing to do with reality. As you can probably tell from my anime pieces, I'm definitely a traditionalist!

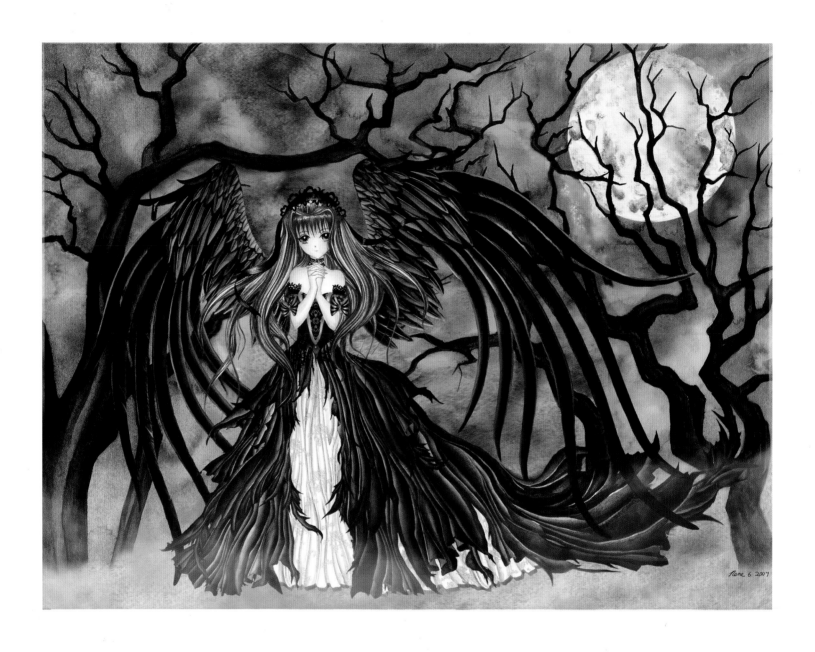

Midnight Wings

This is another anime piece, but with a darker feel. Despite its darkness, it still retains the cuteness inherent in my anime work. YaYa Han, the model for Aria, made a costume of this particular piece, and she wore it at *DragonCon* in 2004. Her costume was stunning and absolutely perfect in every detail, right down to the flow of the wings. Creating a work like this is wonderful, but seeing a living, breathing interpretation of it was truly something special.

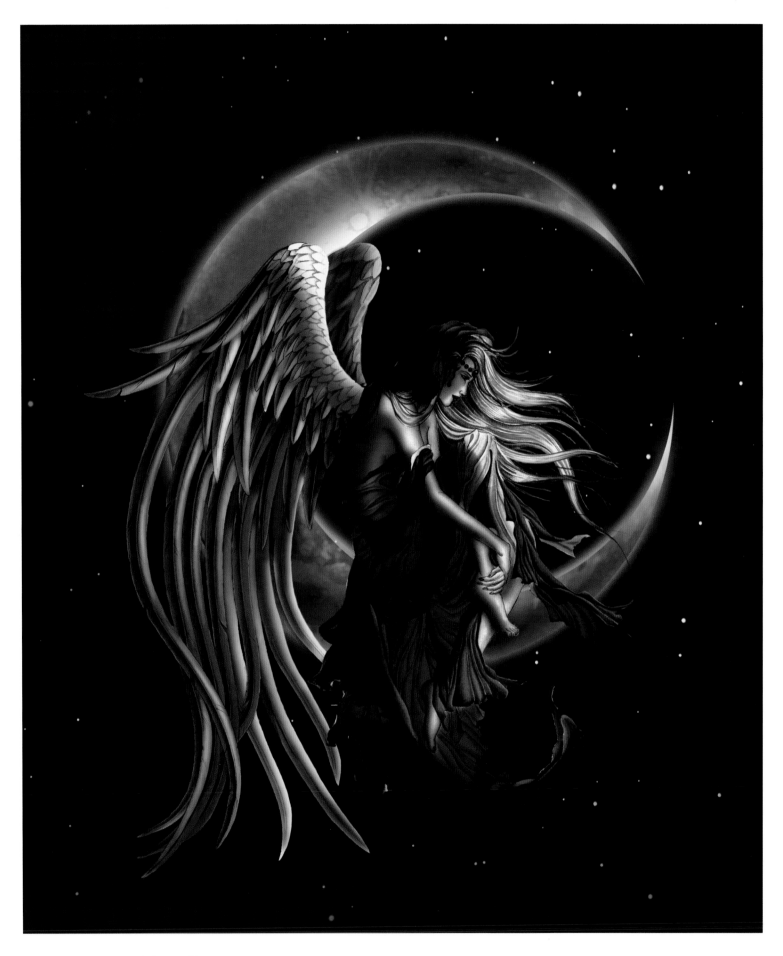

Moon Dreamer

This is a design based on the figure from Introspection that I did for a commission. The soft lighting and the more dramatic shading really works to separate *Moon Dreamer* from *Introspection*. One of the biggest differences is that Introspection had faery wings rather than angel wings, but I thought angel wings were more appropriate for *Moon Dreamer*, considering the subject matter.

Morning Dew

When I work in sets, it's very important to make sure the images are complementary. Evening *Mist* and *Morning Dew* are a little like bookends, two pictures that look good alone but are meant to be together.

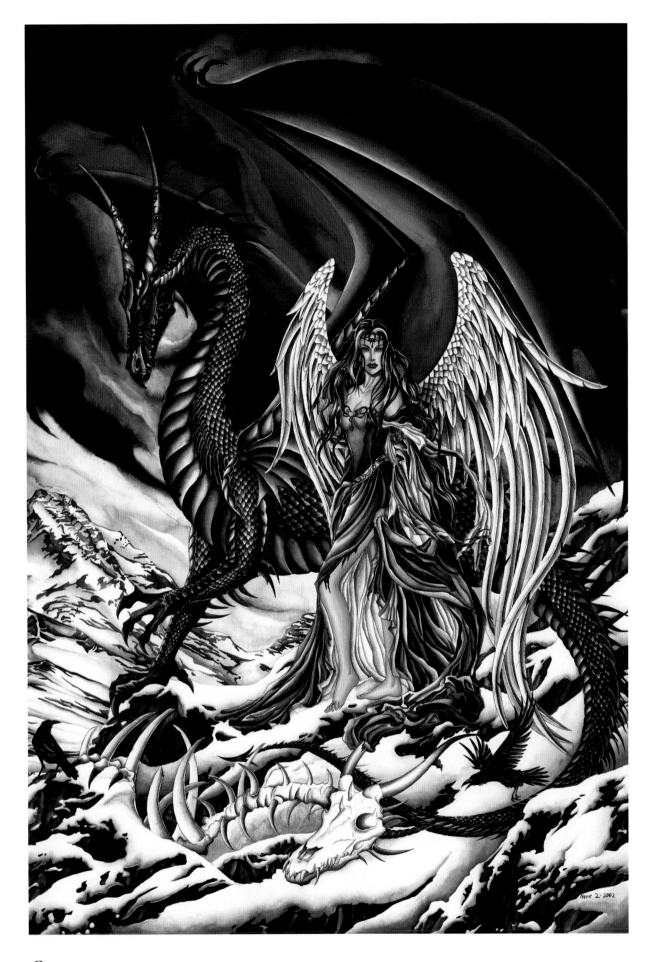

Omen

Omen is a redo of Strength. As I've said before, I love painting winter and autumn scenes, but I have a serious problem with spring and summer. *Strength* was a good idea, but I was really unhappy with the execution. So I took the figure, painted a proper winter background, and then added a dragon for good measure.

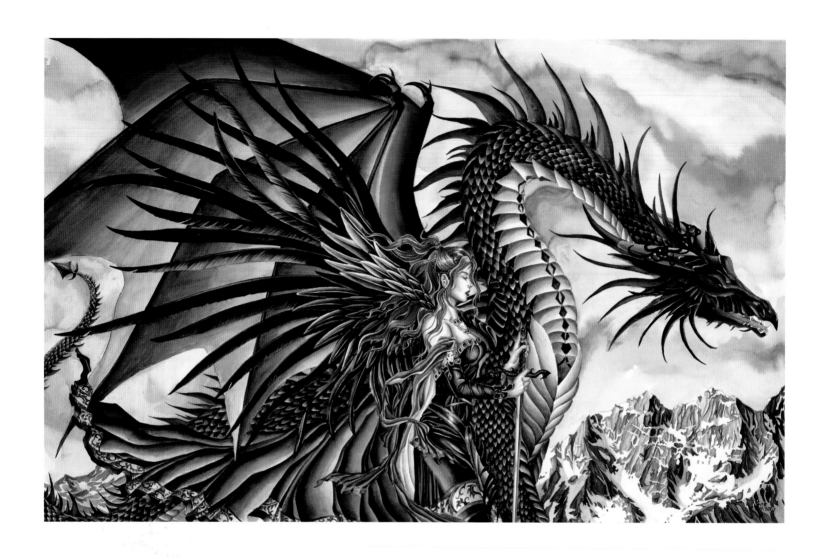

On Ebon Wings #1: Absinthe

The character in this image is a recurring one in my art. Her name is Chesare, and she is one of the main characters in the story that I discussed earlier. The character in *Sapphire*, whose name is Valeriad, is from the same story. These two characters are not a couple. In fact, for all his beauty, Valeriad, as I envision him, is as cold and heartless as Chesare is warm and caring. The two of them find themselves in opposition to each other as the story progresses. These paintings were done originally as character sketches for my story, but they came out so well that I released them as prints.

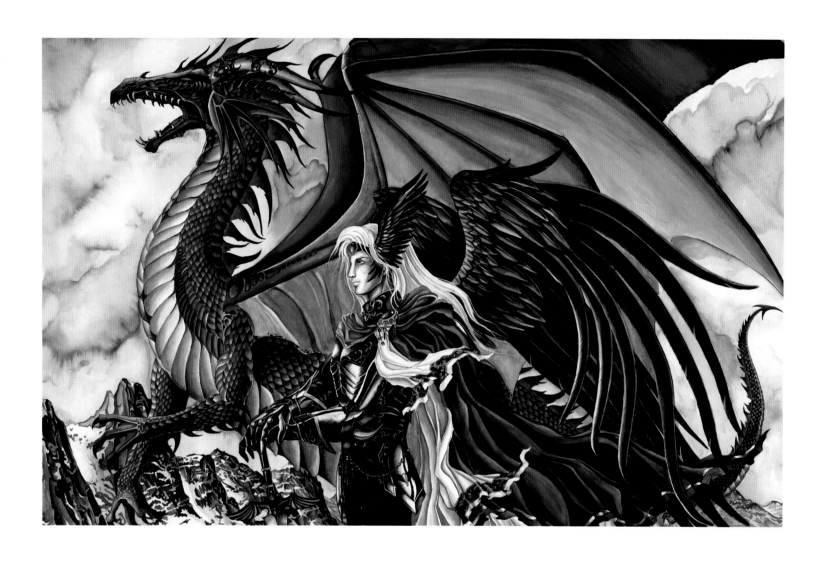

On Ebon Wings #2: Sapphire

The man in this picture actually has a name. His name is Valeriad, and he is a character that I've been working on for most of my life. I hope that one day I'll be able to write about him and the world he lives in, but my writing isn't as good as my painting. Fortunately, the exchange rate is very favorable to artists: if one picture is worth a thousand words, then all I have to do is paint another 150 pictures of him and I'll have a novel!

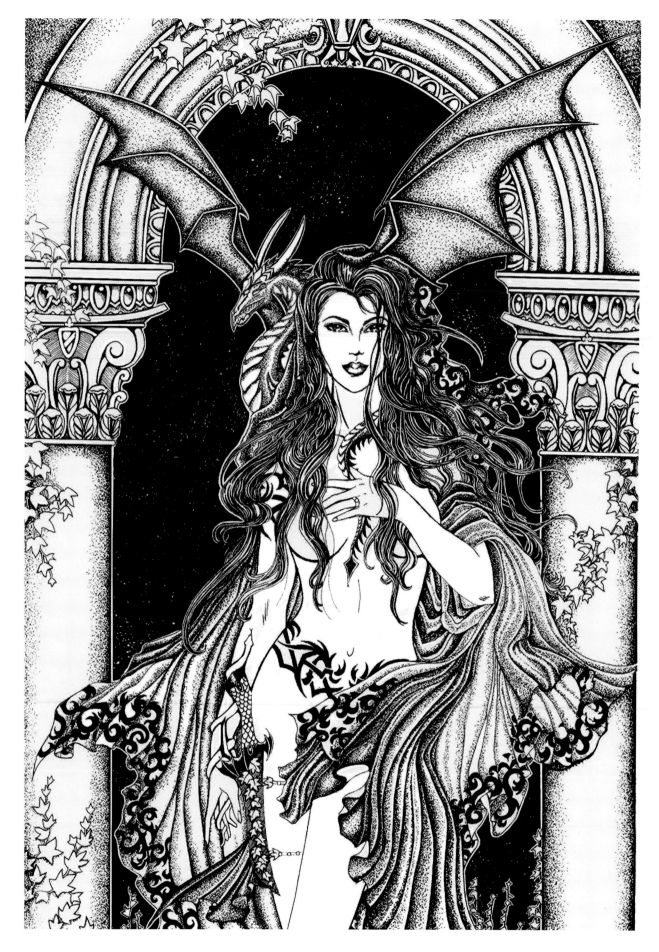

Oracle Pen & Ink

This is far and away my favorite pen-and-ink image. I liked it so much that I had an edition of 100 prints made to see if it would sell, and it did. Sometimes an artist is able to reach beyond his or her skill level and pull out a piece that really stands out. Ann-Juliette accomplished that with *Oracle*, and I couldn't have been more proud of her when it was completed.

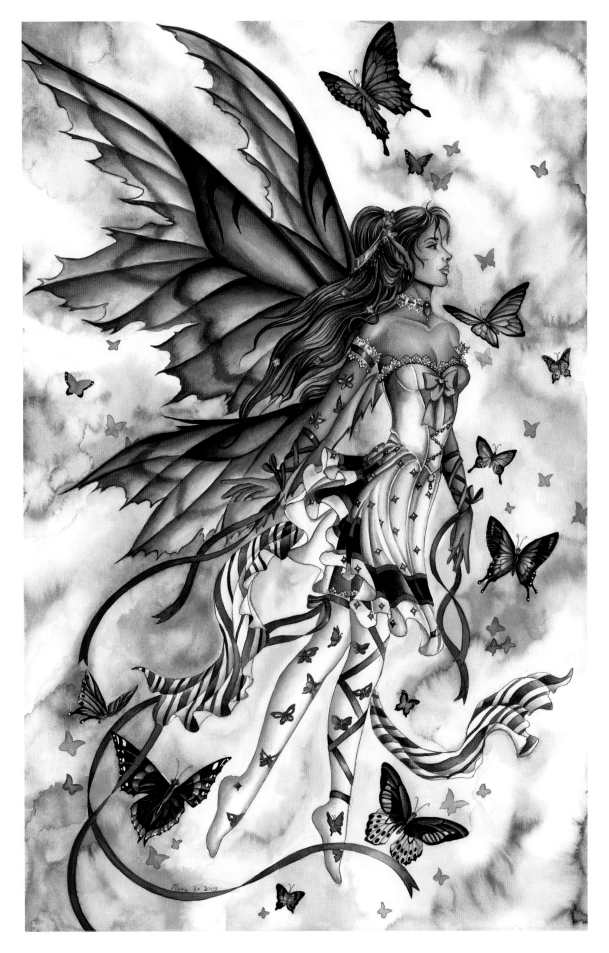

Orchestrals #1: Lavender Serenade

When I designed this piece, I wanted two things: cute and quick. I had been designing really elaborate works for so long that I needed a change of pace. After a little bit of sketching, I came up with the idea for the *Orchestrals*: a series of faeries wearing cute dresses (instead of the formal gowns I normally paint) surrounded by butterflies and nothing else.

81

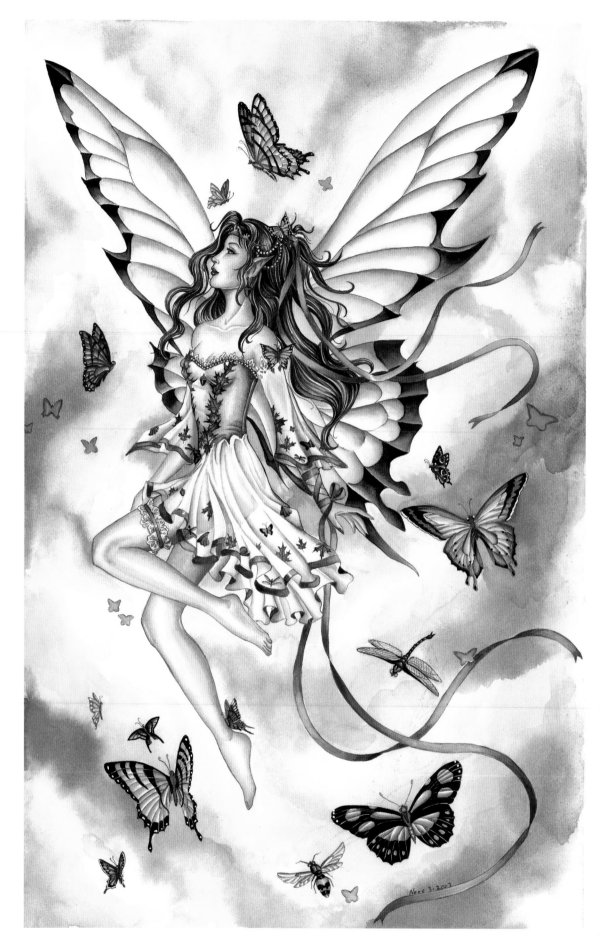

Orchestrals #2: Rhapsody in Gold

This painting is of another whimsical faery, painted with very warm tones to balance the cooler tones that I used in *Lavender Serenade.* I also made her skirt a little more translucent to show off a little more of her legs without being indecent.

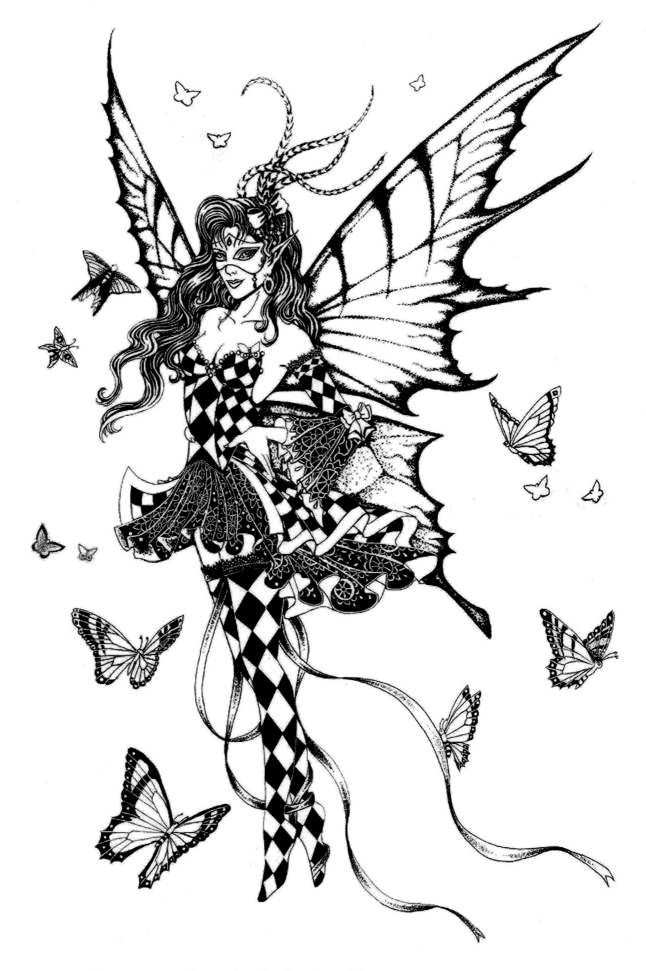

Orchestrals #3: Symphony in Black and White

No matter how colorful I intend a series to be, somehow I always find a way to work the color black into it. This piece just came together. The mask gives the figure a mischievous look, and the rest of the outfit makes her look very playful. Even her hair has a dashing sweep to it, and the jaunty feathers in it complete the look.

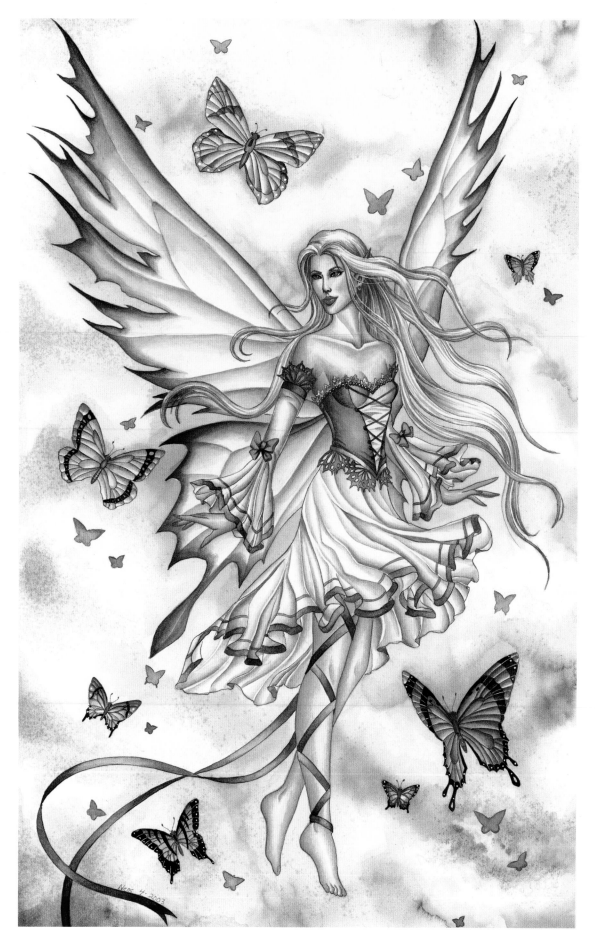

Orchestrals #4: Prelude in Blue

Coming up with interesting titles for pieces can sometimes be almost as difficult as actually painting them in the first place. I wish I could say that the title for this series just popped into my head, but it really didn't. It took days for me to come up with a catchy title that served to tie the images together.

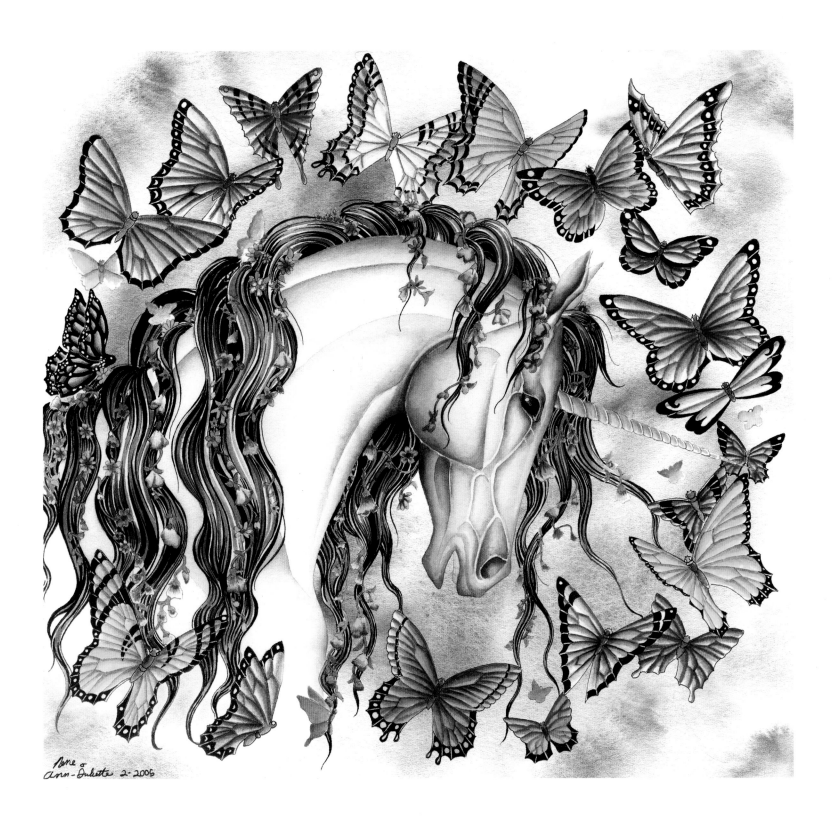

Petal

Up until this piece, Ann-Juliette had been doing very well on pen and inks and color studies, so I felt it was time to push her a bit. *Petal*, and its companion piece *Treasure*, had been sitting on my shelf half-painted for a while, and after careful consideration, I pulled them down and told her to finish them. They took her a while, and I know she sweated bullets over them, but in the end she pulled them off flawlessly.

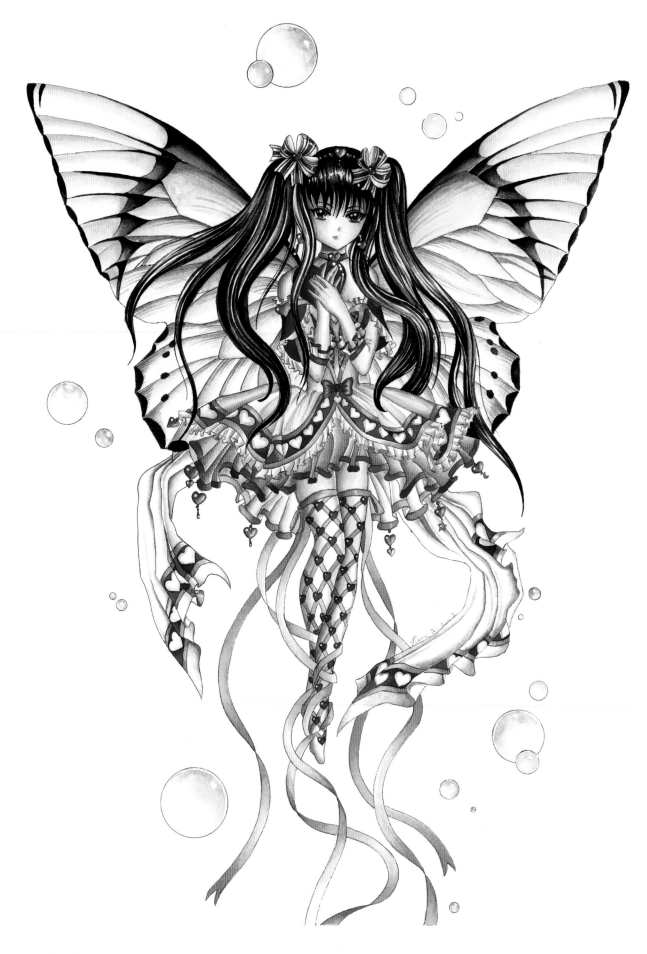

Pink Champagne

Next to *Candy Cane*, *Pink Champagne* takes the prize for being the most adorable faery. While the dress has a very definite Valentine motif, it isn't a true holiday image like *Candy Cane*. My sister Ann-Juliette helped me create the dress design for this image and for *Red Hearts*.

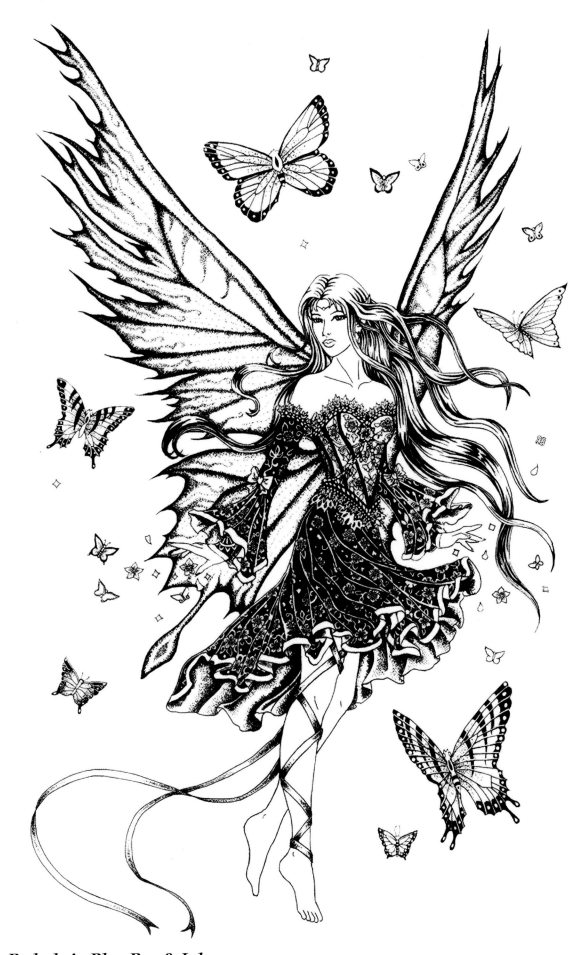

Prelude in Blue Pen & Ink

By the time Ann-Juliette did this one, she had become an old hand at doing the *Orchestrals* as pen and inks. This design follows the groundwork she laid in the other three designs, and the four together forms a cohesive whole. It's interesting to see that the heavy pen work doesn't extend to the skin on any of her inks. She puts the heavy detail on cloth and other elements but lets the drawing speak for itself when it comes to flesh.

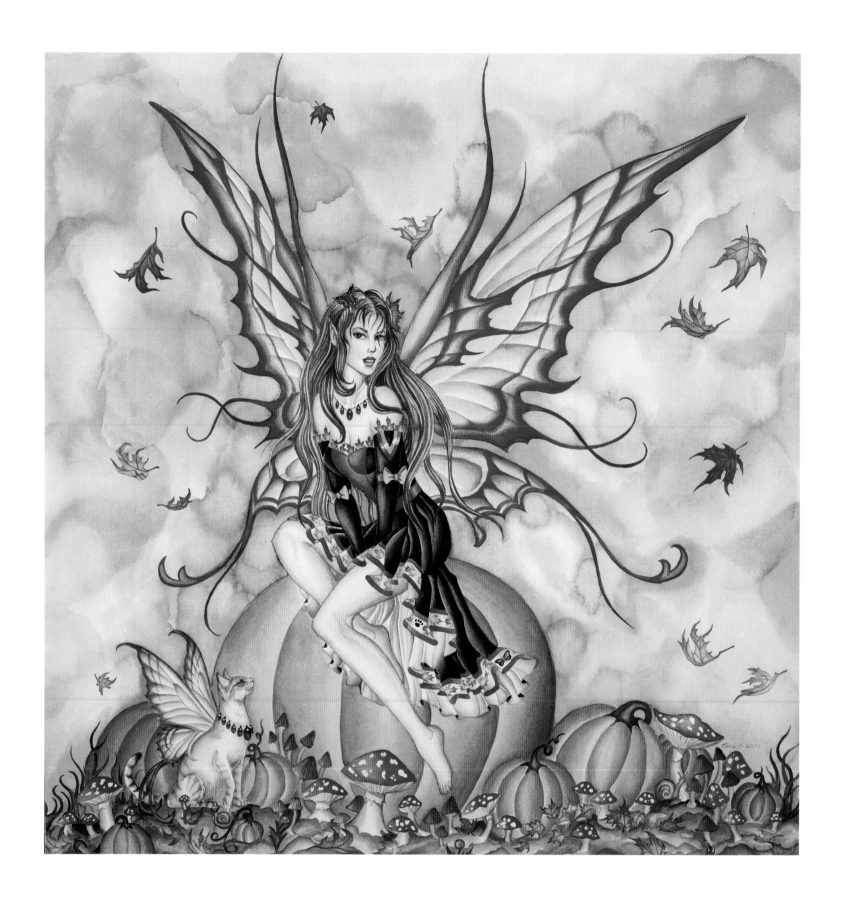

Pumpkin Patch

Much like *Pink Champagne*, *Pumpkin Patch* isn't actually meant to be a holiday-specific painting. Pumpkins just seem to represent Halloween or Thanksgiving. I simply wanted to paint some bright orange wings and I needed a design element that would work with that color. Having the figure sit in a grove of orange trees wouldn't have produced the same feel. Ann-Juliette did a lot of the design work on this image, including laying out the pumpkins!

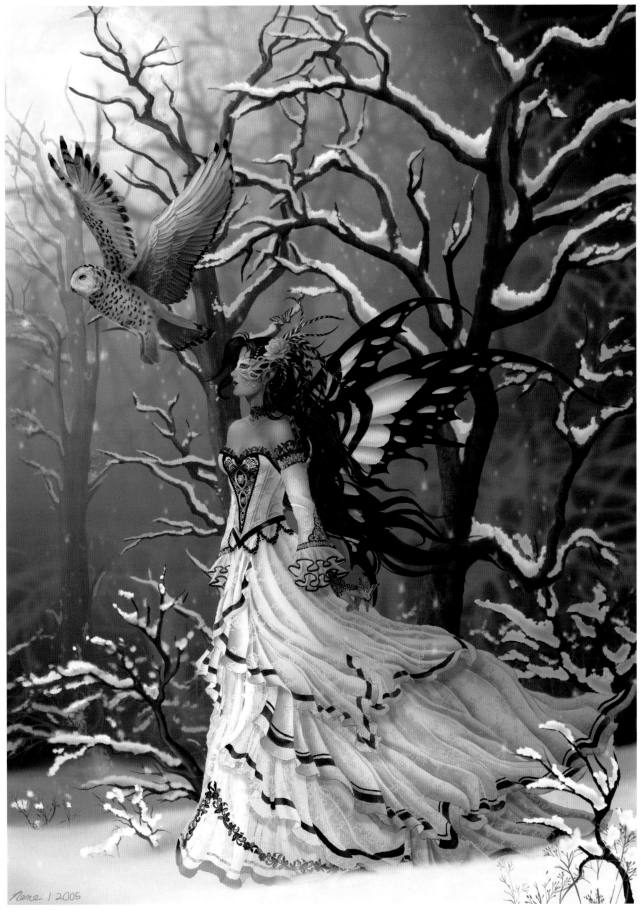

Nene / 2005

Queen of Owls

As my style continues to develop, I find that I am able to capture more and more of the image that I seen in my head on the drawing board. This is very satisfying to me, for one of the great heartbreaks of being an artist is the constant need to compromise or settle. Time and again, I look at a painting and think to myself this isn't how I imagined it or this isn't how I pictured it in my head. *Queen of Owls* has come closer to matching the image in my head than any other piece I've painted so far.

89

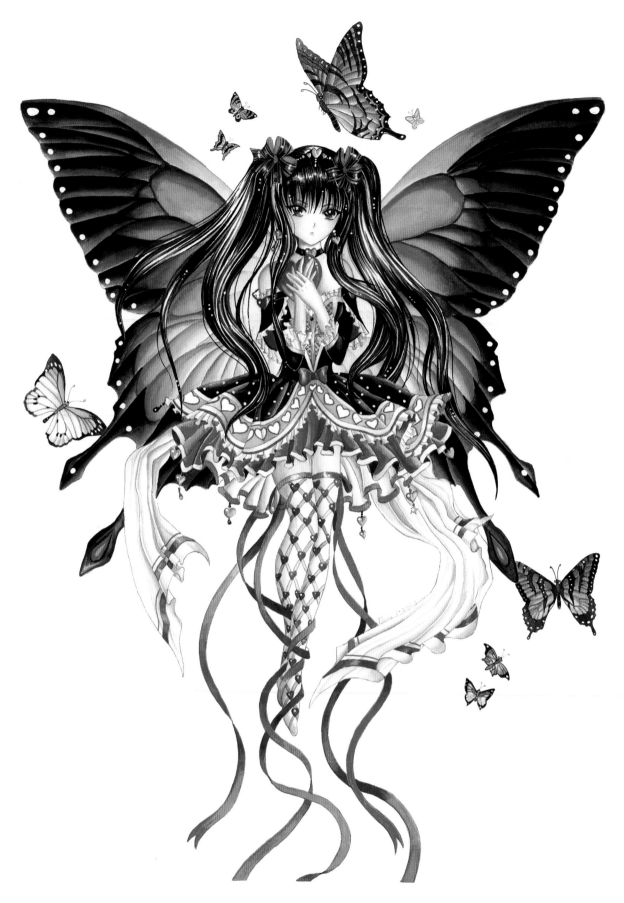

Red Hearts

Long before I decided to become a professional artist, I was a fan of Japanese animation. I used to draw my favorite characters and submit them to various fan publications, and eventually people began to ask me if I had any prints available. People wanted to pay me to draw? I couldn't believe it. Years later, anime has become one of the fastest growing segments of the fantasy industry. While traditional conventions are faltering or dying, anime conventions are growing like wildfire. So I decided to try my hand at Anime again, to see if I still could do it well.

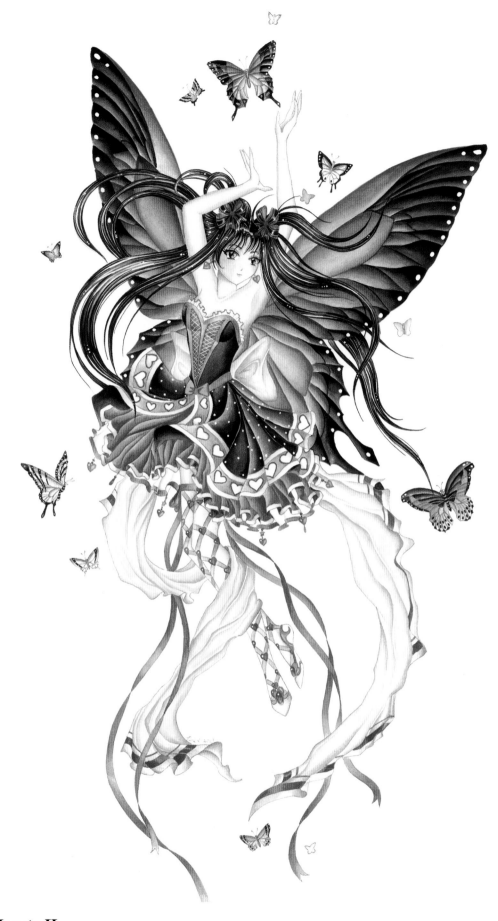

Red Hearts II

Red Hearts did very well as a print, but it also did very well in the realm of merchandising. It seems that after all these years, anime is becoming mainstream, and major corporations are picking up on that. *Red Hearts 2* was commissioned by a company that wanted me to do a version of *Red Hearts* with a more dynamic pose. I was more than happy to oblige, for I really liked the way *Red Hearts* came out in the first place.

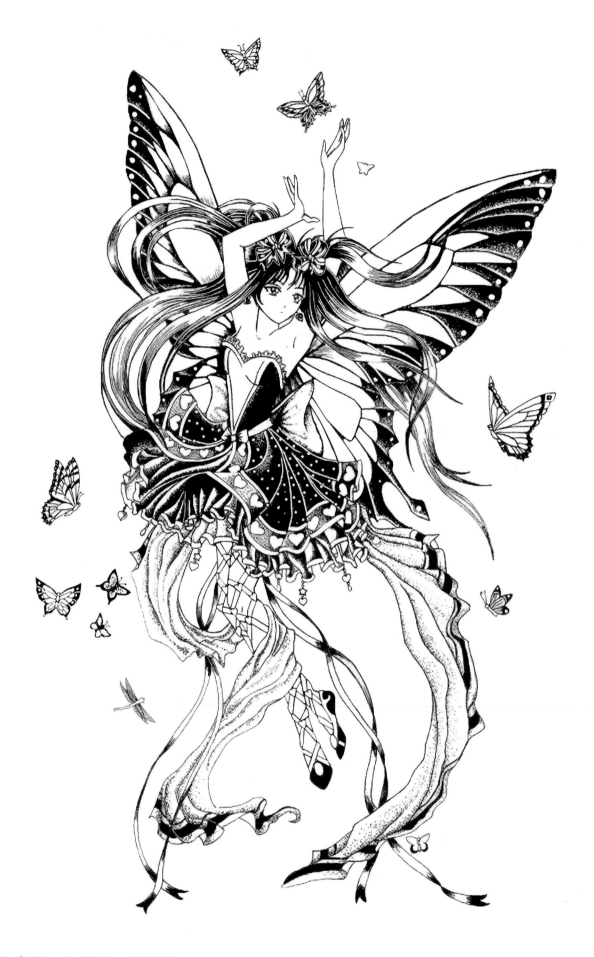

Red Hearts II Pen & Ink

Normally, Ann-Juliette takes any opportunity to turn plain cloth into elaborate patterns and intricate designs. When she set to work on *Red Hearts II*, she decided against that and instead kept the pen and ink as close to the original painting as she could get it. I think she made the right decision, as heavy detail looks out of place on anime art.

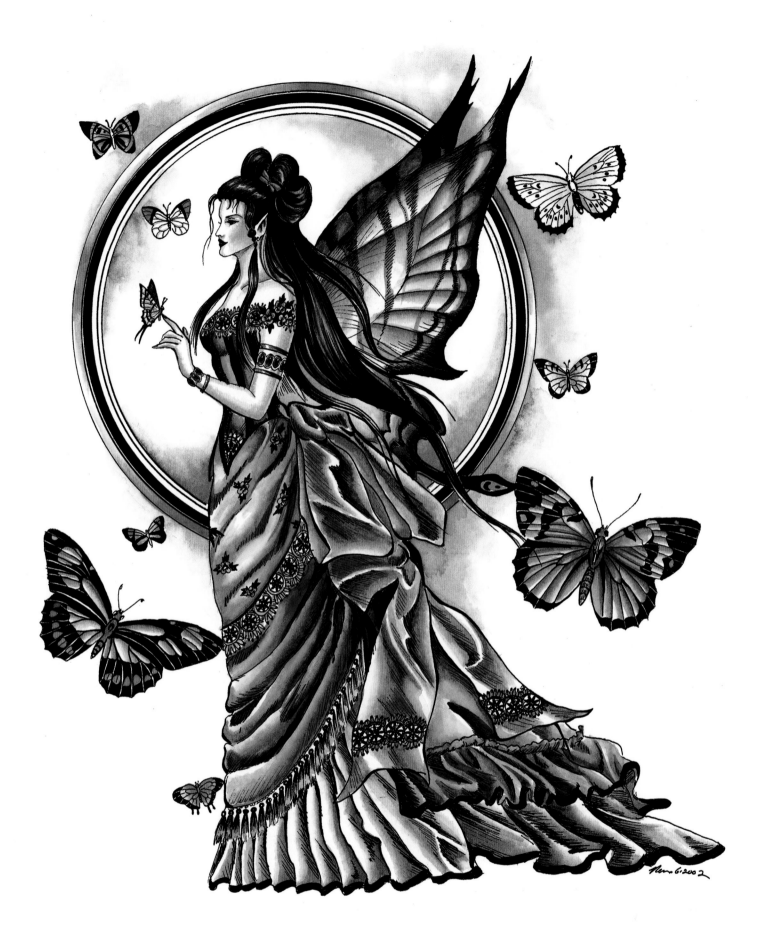

Regal Beauty: Emeralds

This painting is of a faery wearing a Victorian day dress. When I finished this drawing, I knew it wouldn't really have a mass appeal, so I released it as a series of ten hand-colored prints.

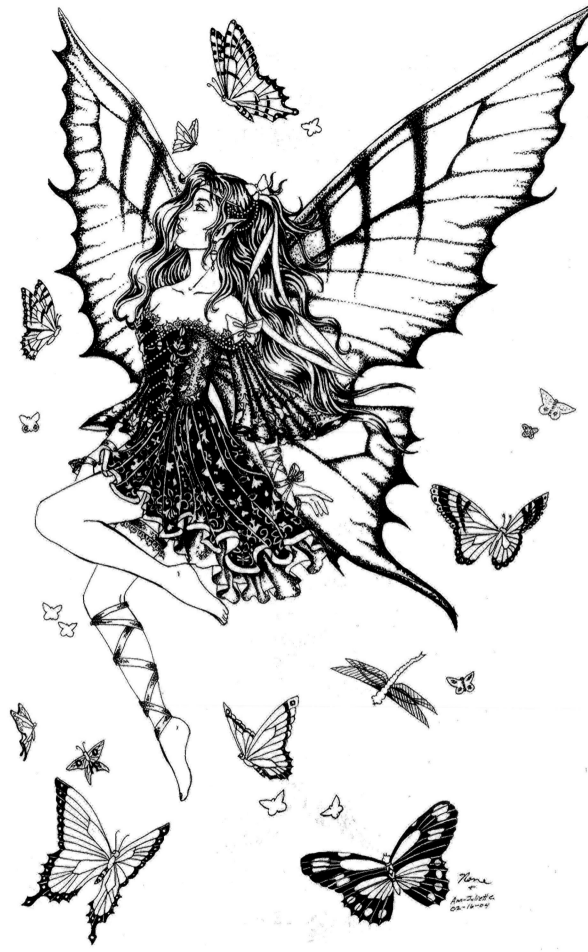

Rhapsody in Gold Pen & Ink

Rhapsody in Gold is one of the *Orchestrals*, and you can see the color version of the figure in this book, but the pen and ink came out so well that I thought it should be added for posterity. As with all of the pen-and-ink images in this book, the original sketch was done by me, but all of the ink work was done by my sister Ann-Juliette.

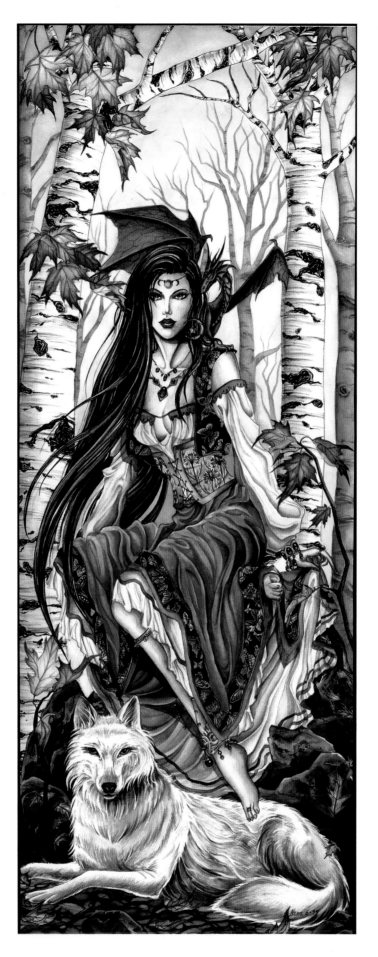

Sisters #1: Misty Morning

This gypsy is the first in the *Sisters* set and is designed to stand beside *Corsair*. When I painted this piece, I wanted to show two sisters whose lives had taken radically different paths. On a side note, if you look at this sister's foot, you will see that she is missing her big toe. My husband keeps saying that the wolf ate it.

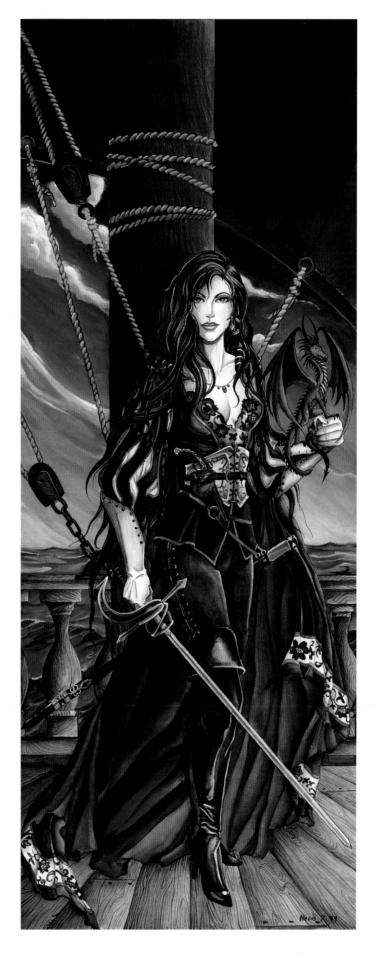

Sisters #2: Corsair

Corsair is the second part of the *Sisters* series, which was designed to show two sisters who had lived very different lives. The only problem with this picture is the figure's skin tones. A true sailor would be deeply tanned, not milky white.

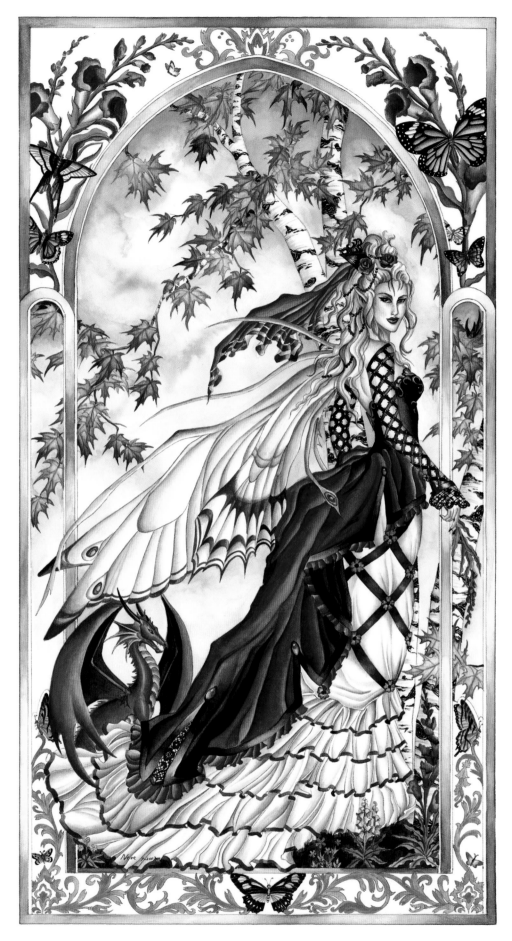

Snapdragon

The sleeves on this figure's dress were inspired by a costume worn by one of my favorite ice skaters, Irina Slutskaya, at the 2001 World Championships. Irina only took second, but she looked incredible. The rest of the dress has a Victorian design with lots of flowing cloth, just the way I like it!

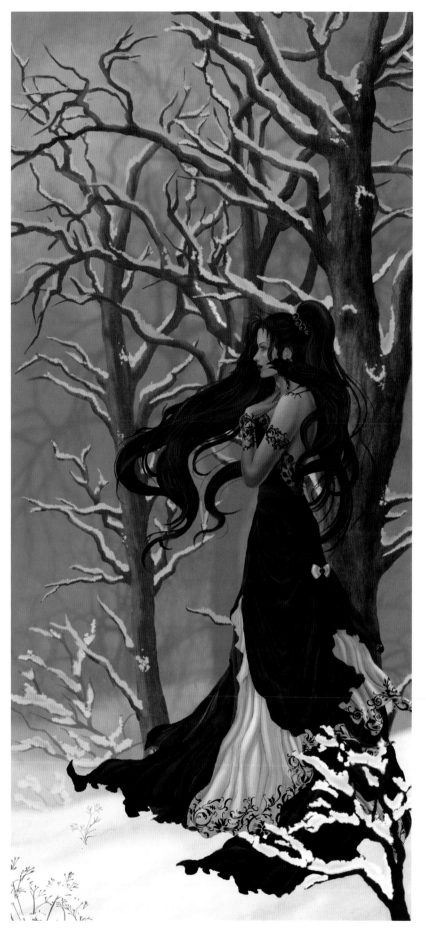

Solitair

The red hair color of the figure in *Solitaire* is the only true color in the entire piece. It serves to draw the eye straight to the center of the painting. The rest of the painting is a study in monochromatic lighting, and it isolates the character very well, making her a solitary figure, not just in the drawing, but in the painting as well. This is another painting of Chesare Dar, the character in *Absinthe, Memento, Bird of Prey,* and *Fall.*

98

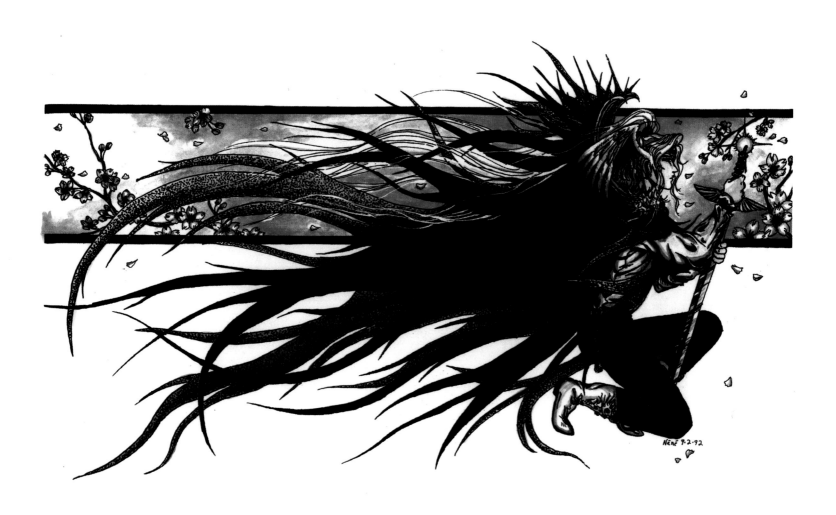

Spring

Much of my earliest work tended to feature characters from my story. This is another picture of Valeriad, the character that I painted in *Sapphire*. A lot of these early pieces also featured artistically tattered (usually black!) cloth. I moved away from the motif for a while, but I've since been experimenting with it again. *La Victime*, *Hope*, and *Storm Runes* are some of my latest pieces, and all of them feature clothing that has been artfully torn.

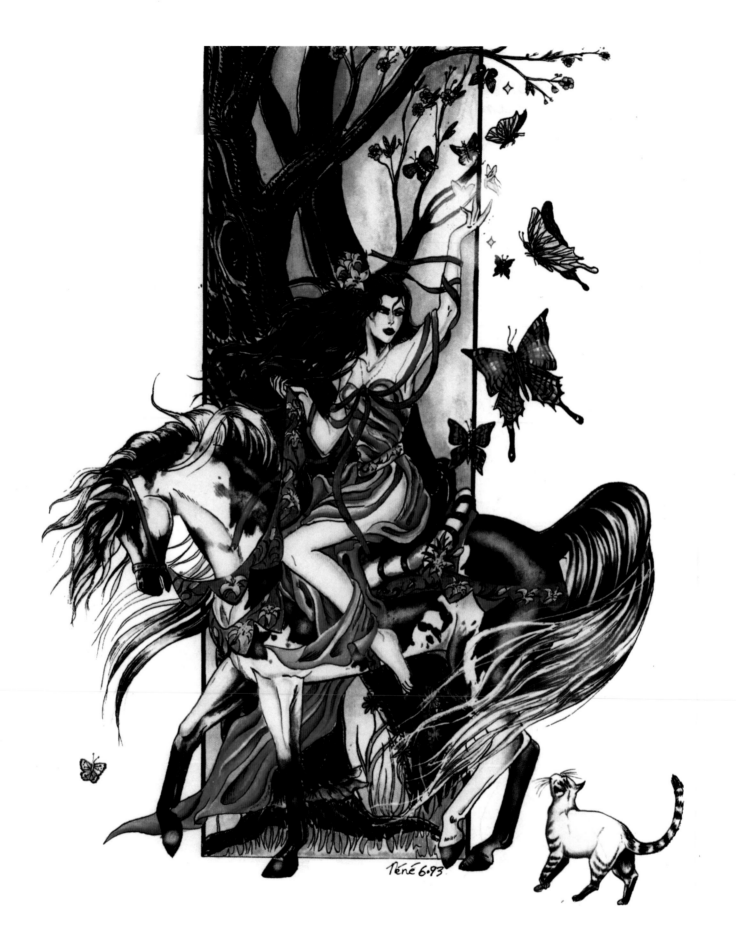

Spring Faery

I've used the idea in this piece several times throughout my career, but this is one of my earliest examples of a faery sitting on a horse. For purely aesthetic reasons, I really prefer to paint women sitting sidesaddle, as in Faery of Black Cats, rather than sitting astride as the faery in this piece is doing. Having a faery sitting sidesaddle just seems more elegant to me.

100

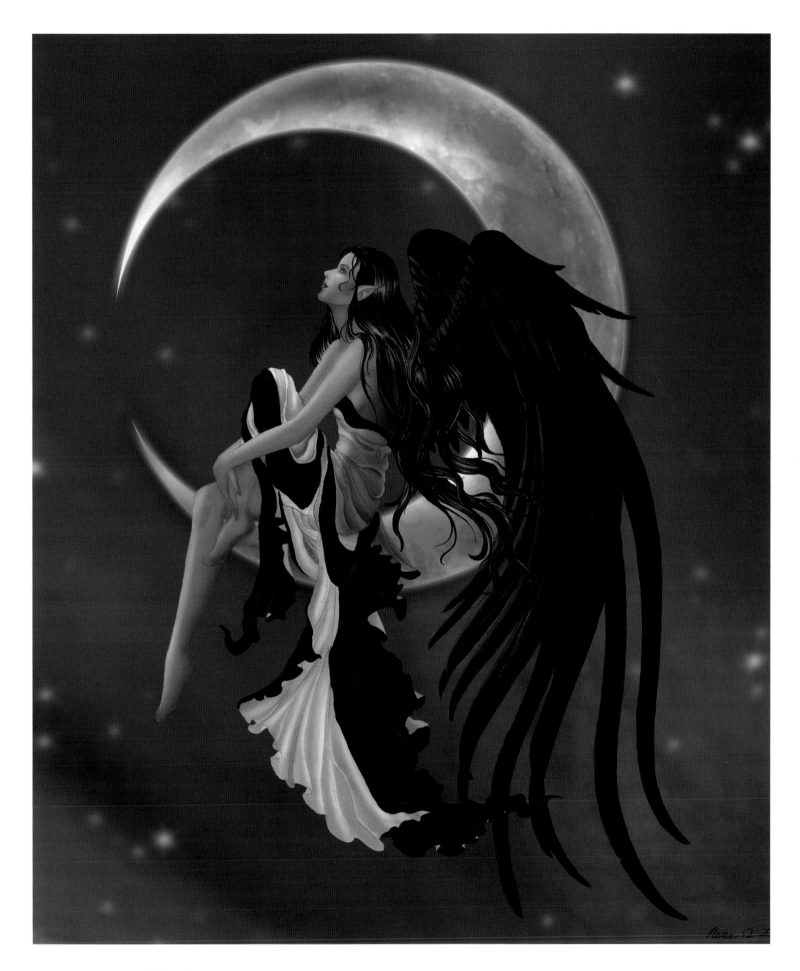

Stargazer

Stargazer was designed as a companion to *Moon Dreamer*. I worked a long time on this painting and believe the end result is good, but it didn't come out as I imagined it would. I can't put my finger on it, but something about this one strikes me as odd. Still, I really like the dreamy look on the figure's face and the fact that she is staring at the stars as if she is imagining what is out there.

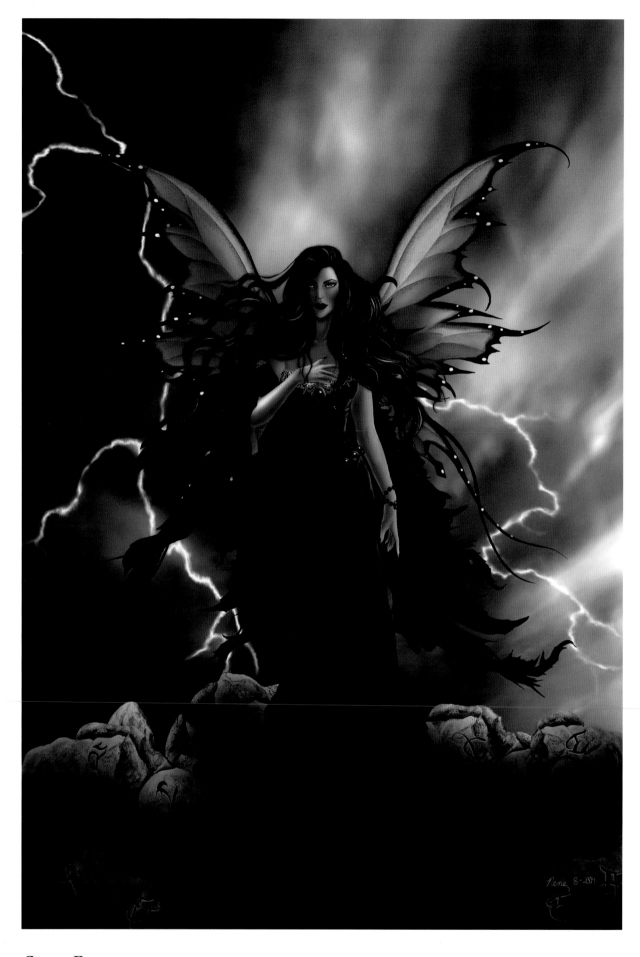

Storm Runes

Storm Runes is a very dramatic piece. I really went out of my way to make the lighting as intense as possible without overpowering the piece, and I really like the results. I couldn't decide between faery wings and large black feathery wings, but I eventually decided that feathery wings would be a little too much for an already dark piece. The purple wings really work with the lightning too!

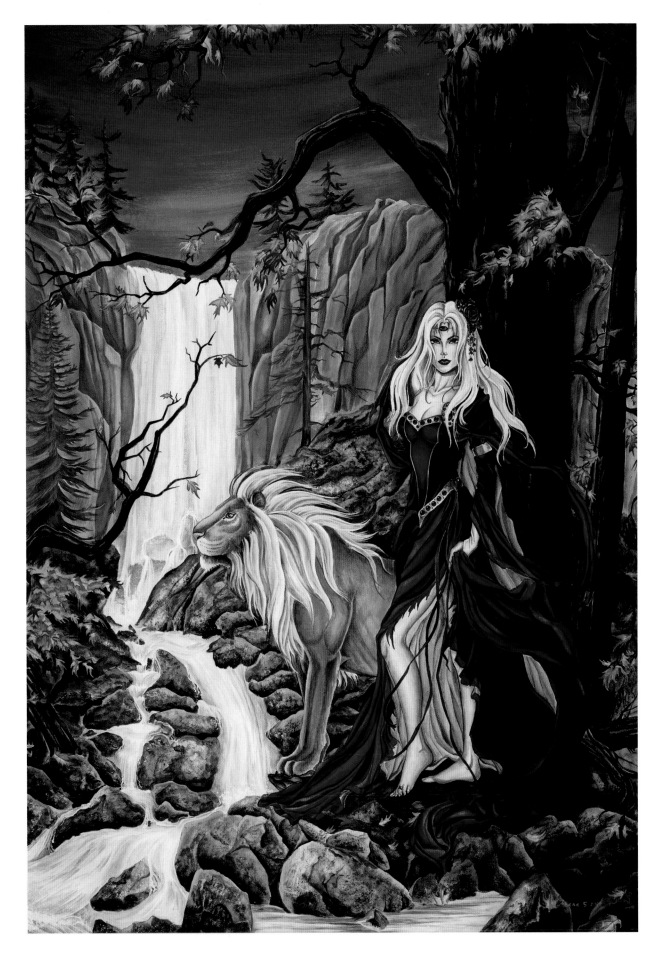

Strength

This piece looked really good as a sketch, but the execution came up a bit short. The woman, the dress she's wearing, and the rocks in the foreground came out great, but the lion and the background needed some work. Unfortunately, the more I worked on it, the worse it seemed to get. Out of sheer frustration, I went back to the drawing board and created *Omen* instead.

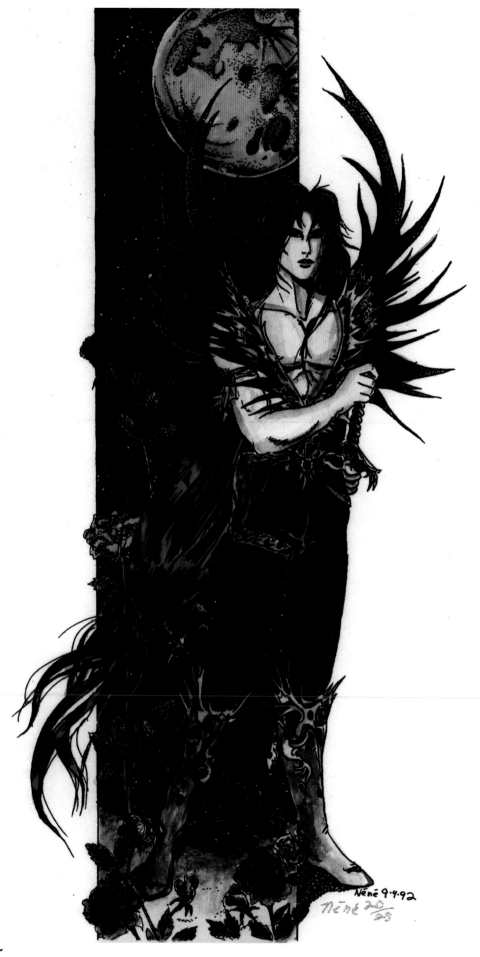

Summer

The figure in this piece is a very early incarnation of a character from my story named Derentain. Long hair is great, but I think I went a bit overboard here. The manly chest and the too-small shirt might also be a bit much.

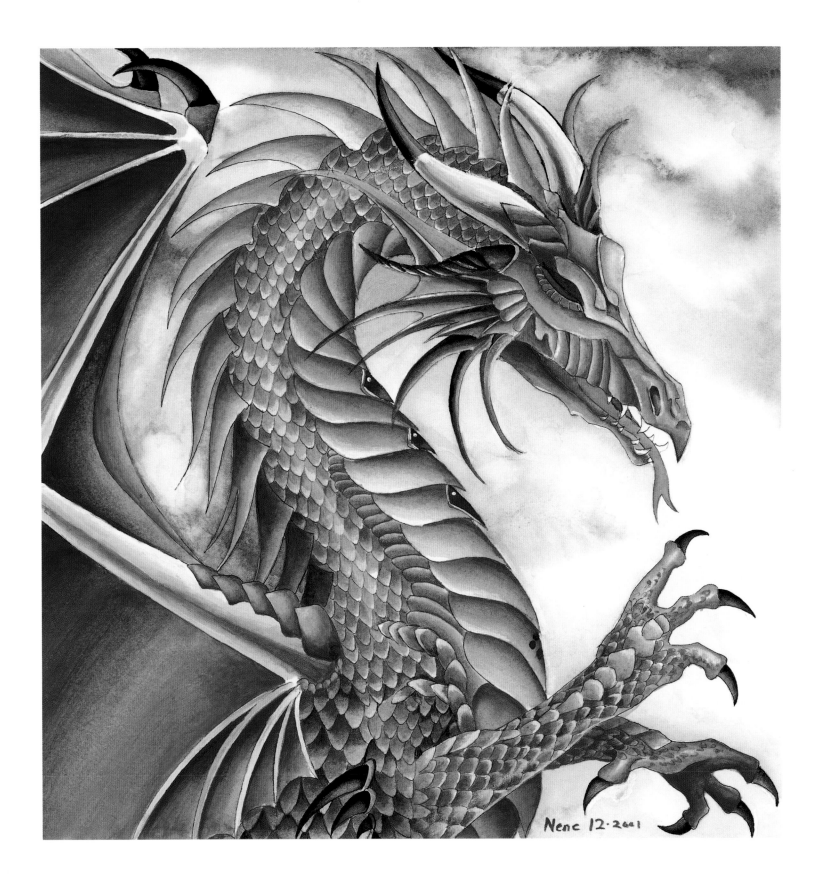

Nenc 12·2001

Sundancer

A good percentage of my fan base is made up of gamers (people who play role-playing games such as Dungeons and Dragons), so I often get asked to paint specifically colored dragons. *Fireheart*, the companion piece to *Sundancer*, was tailored for my fans who are gamers. Golden dragons are amongst the most noble and most revered creatures in the fantasy world. As such, they make an excellent opposite to vile black dragons. And for the gamers reading this right now: Yes, I know the true match for a golden dragon is actually a red dragon and NOT a black dragon, but black dragons are much prettier!

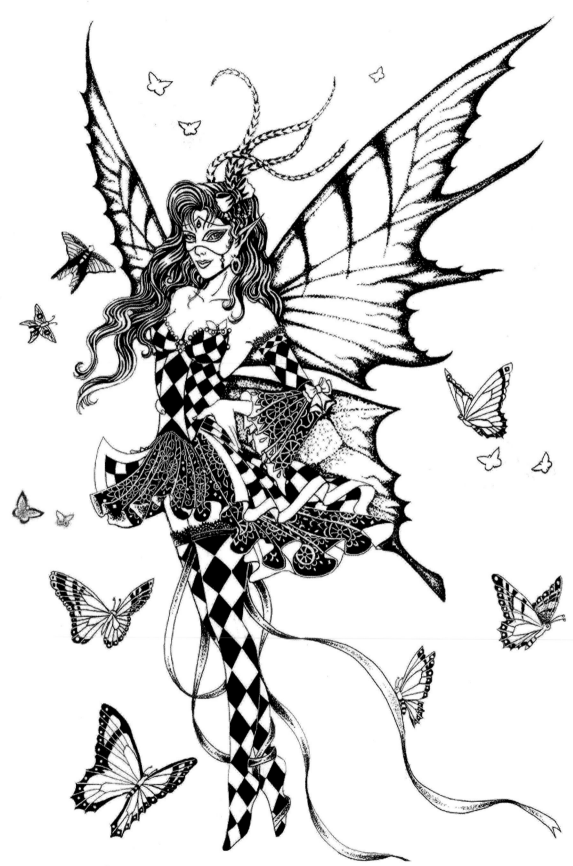

Symphony in Black and White Pen & Ink

You would think that a piece entitled *Symphony in Black and White* could be easily converted into a pen-and-ink original, but you'd be wrong. As with almost all of her pieces, Ann-Juliette takes special care to flesh out all of the plain cloth with elaborate designs to make them more visually stimulating. The patterns actually serve to tone down the visual cacophony that a stark black-and-white image creates.

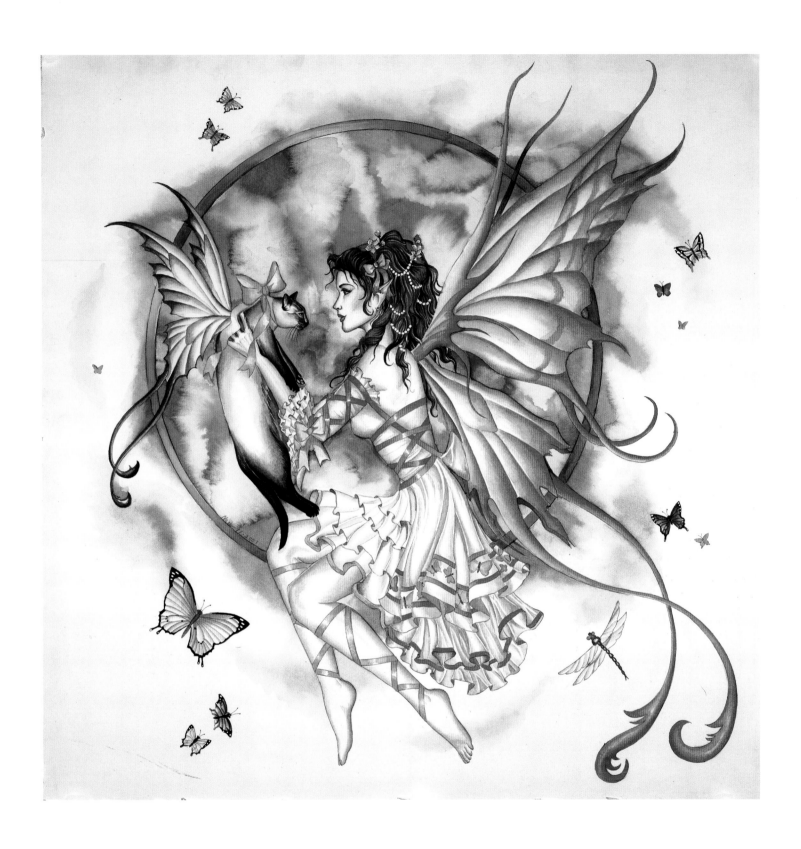

The Gift

Siamese cats are absolutely adorable, which makes them the perfect breed to feature in a piece called *The Gift*. Unfortunately, while they may look great, they have a reputation for being noisy, destructive, and very, very high maintenance. My mom had a Siamese cat named Coco-chin, and she was a right terror, though she was very beautiful. And of my six cats, one is a blue-point Siamese, and another is a Siamese/Himalayan/Persian mix. Both cats are beautiful, but sadly, they go out of their way to perpetuate the stereotype.

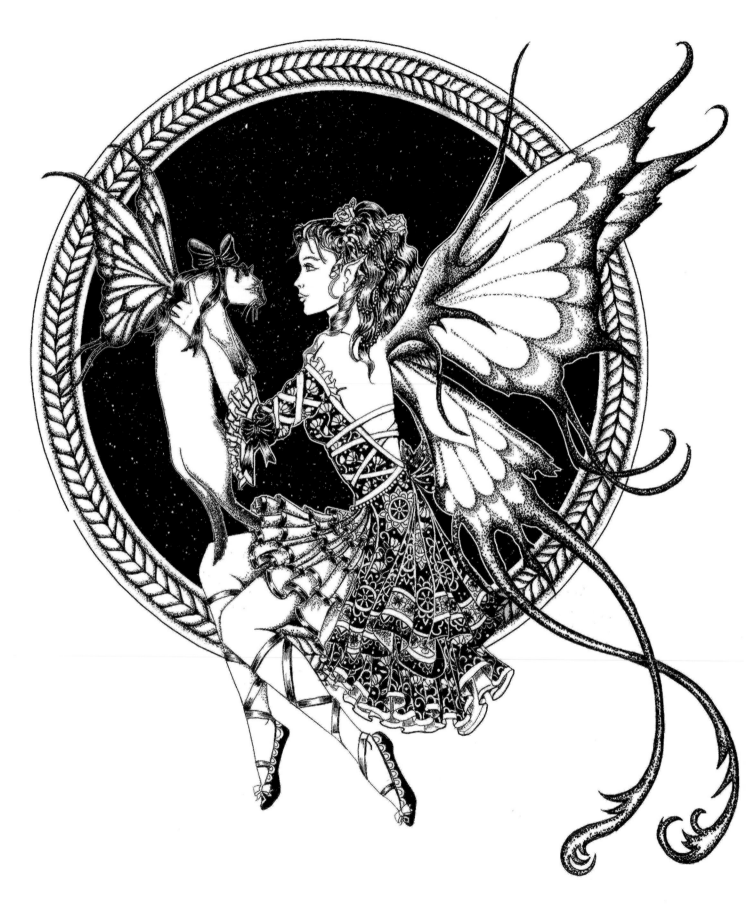

The Gift Pen & Ink

The dress in the original painting was pink, plain and pink. Sadly, pink doesn't translate to black and white so, to compensate, Ann-Juliette came up with one of her most elaborate designs.

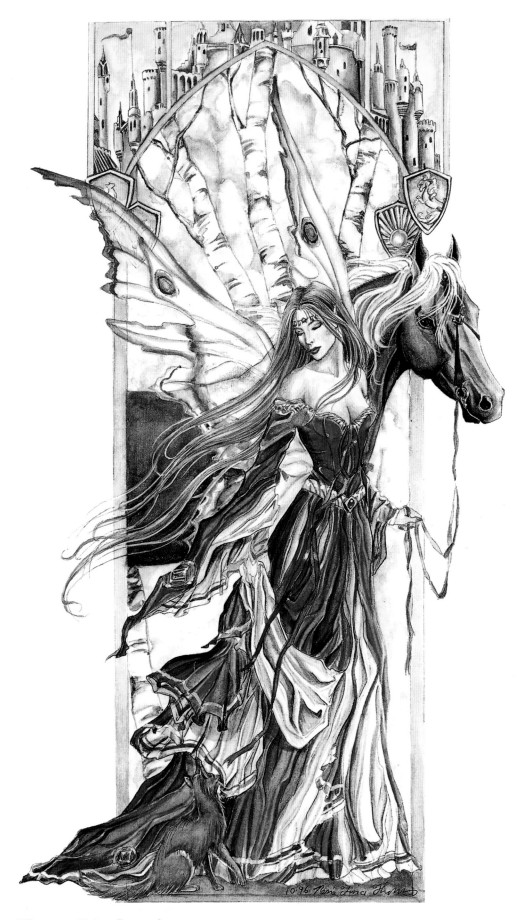

The Virtues #1: Serenity

I really didn't like this piece when I completed it. Most artists know what I mean when I say that sometimes a picture just doesn't come out the way you imagined it would. *The Virtues* was only supposed to be a series of four, but I was so disappointed with *Serenity* that I set it aside and painted four stronger images. For some reason, everyone else loved this one. Sometimes an artist just isn't the best judge of his or her own work.

109

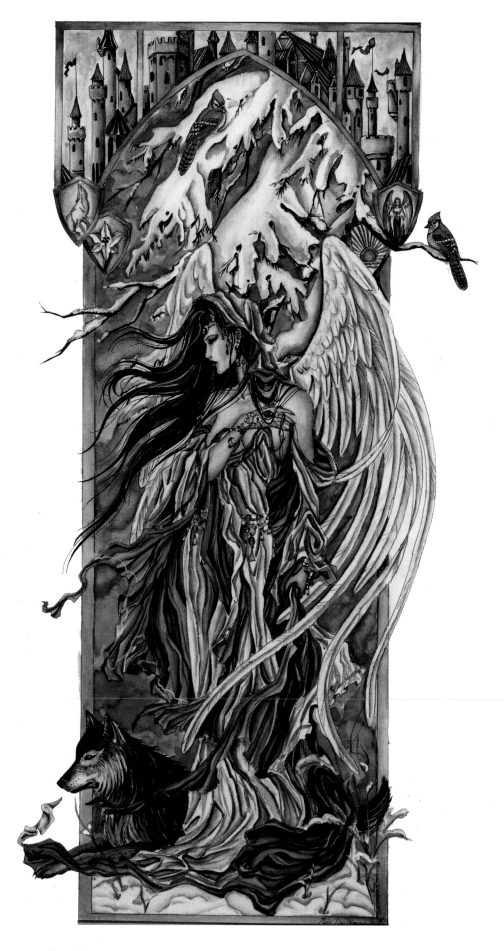

The Virtues #2: Peace

Peace represents winter. *Serenity* was the prototype, for I actually intended for the *Virtues* to be a series of four—containing an image for each season.

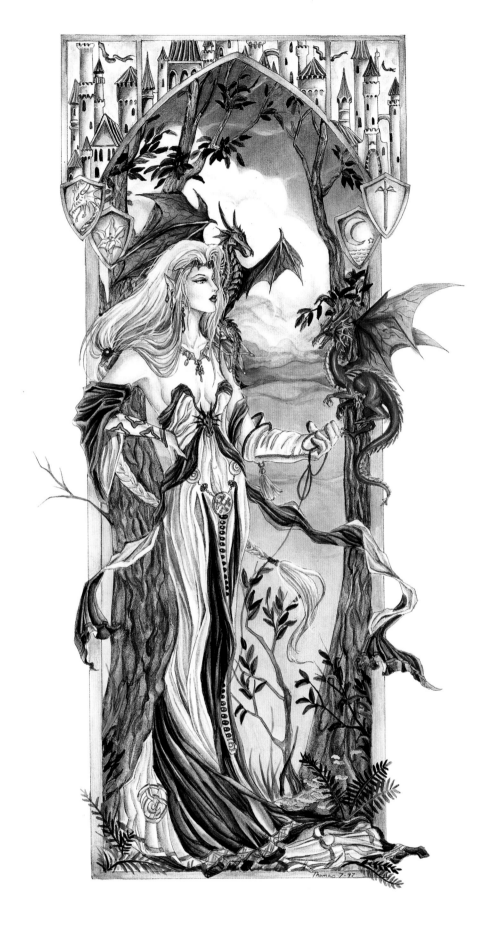

The Virtues #3: Elegance

Elegance represents summer. The thing I like best about this image is the arrogance that the figure radiates. In popular fantasy, elves are the most arrogant creatures, and I think I captured that arrogance with this figure's pose and expression.

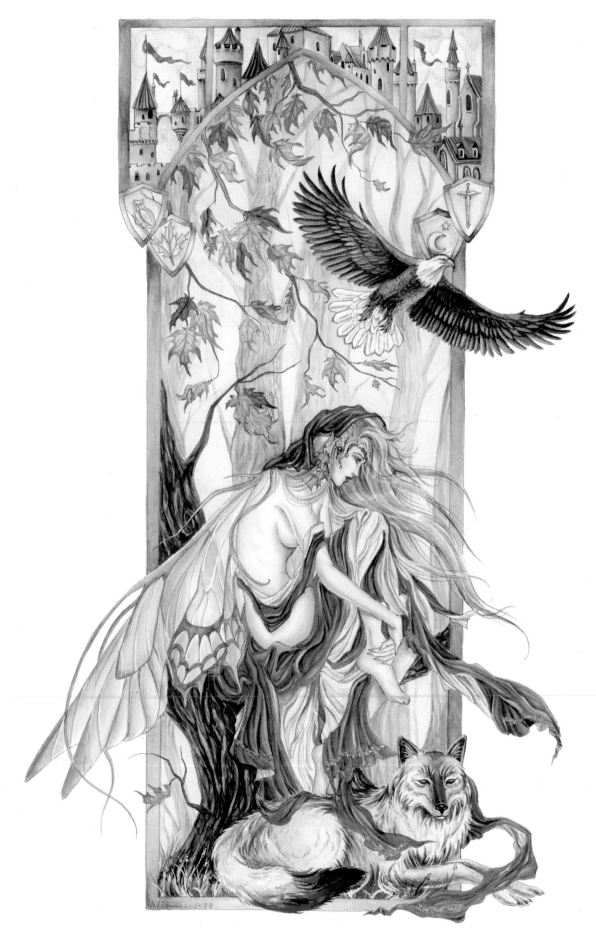

The Virtues #4: Introspection

Introspection represents fall. I have used the figure in this piece several times, because it is one of the most evocative figures I've ever created, and several companies have asked me to modify it for them.

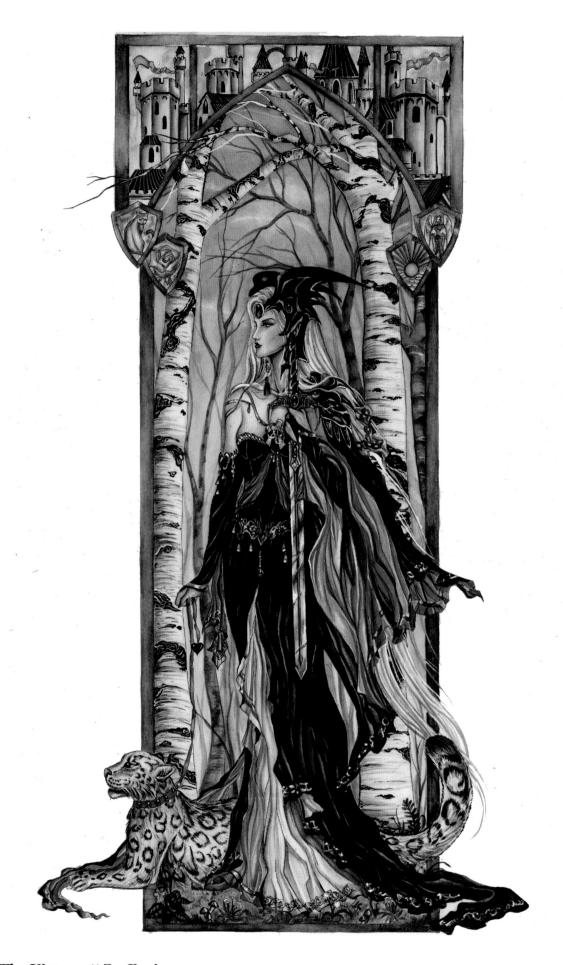

The Virtues #5: Patience

Patience represents spring and was the last of the *Virtues* to be painted. The figure has the same cool expression that *Elegance* has, but it is not quite as pronounced. I drew her holding the sword as if it didn't actually belong to her. I wanted her to look as if she were simply holding it in trust for someone else.

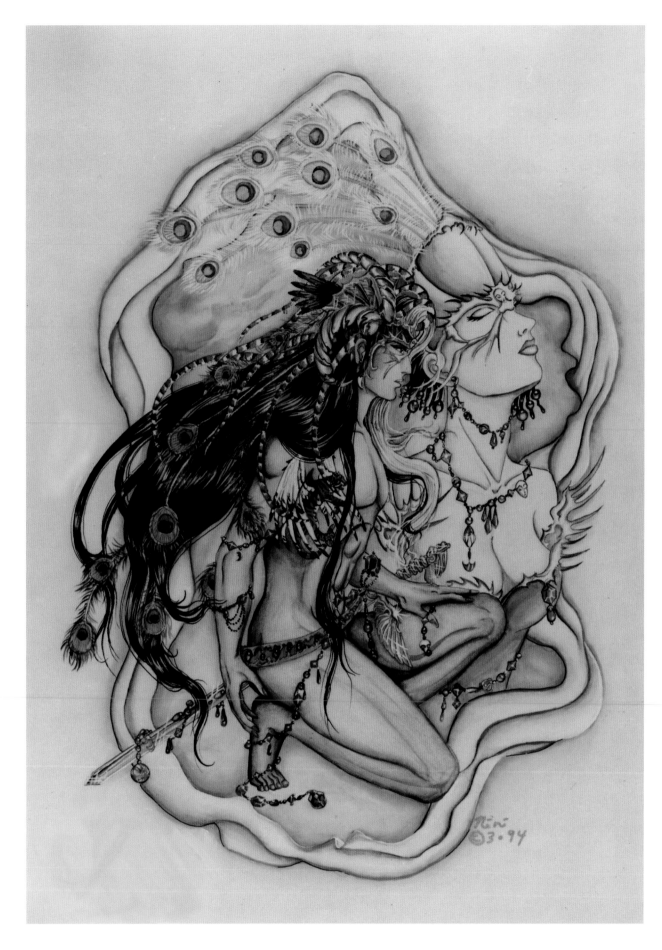

Tiger Prince

This is Phaedron, another character from my story. He's Valeriad's brother and Chesare's lover. While he is a major character in the story, I haven't really used him much in my art. I prefer the cold look of Valeriad to the warm look of Phaedron when I paint men.

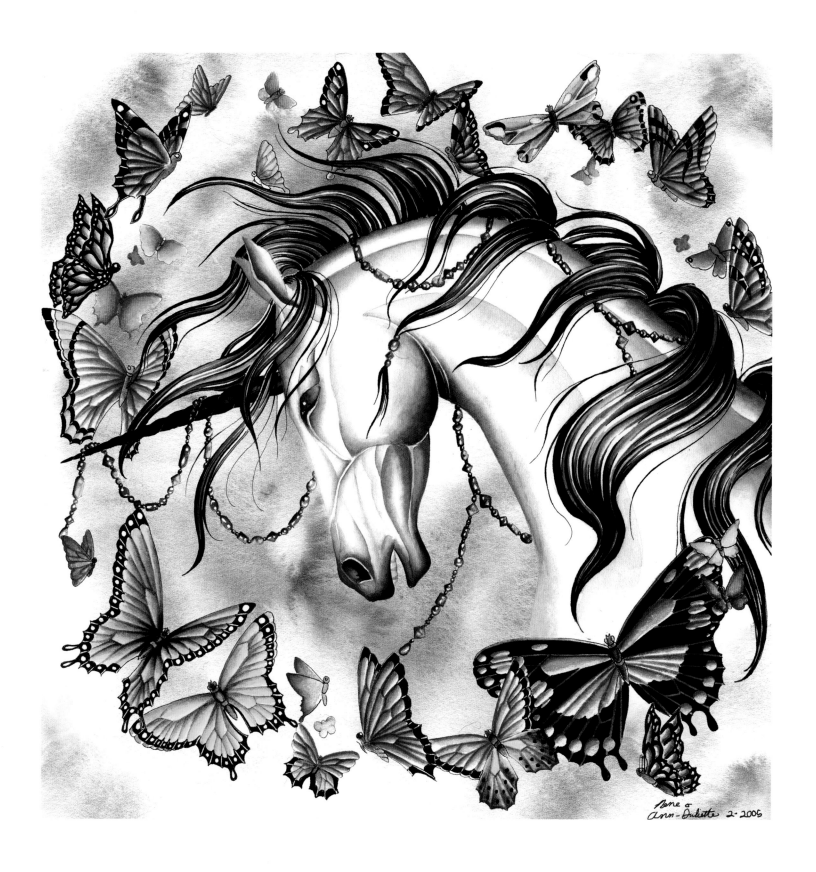

Treasure

As with *Petal*, this piece was set aside after I had started it because I didn't like the direction it was taking. When it came time to train Ann-Juliette on color work, I immediately thought of this piece and *Petal*. The myriad butterflies gave Ann-Juliette the perfect chance to use all of the colors on her palette, and she took excellent advantage of the opportunity.

115

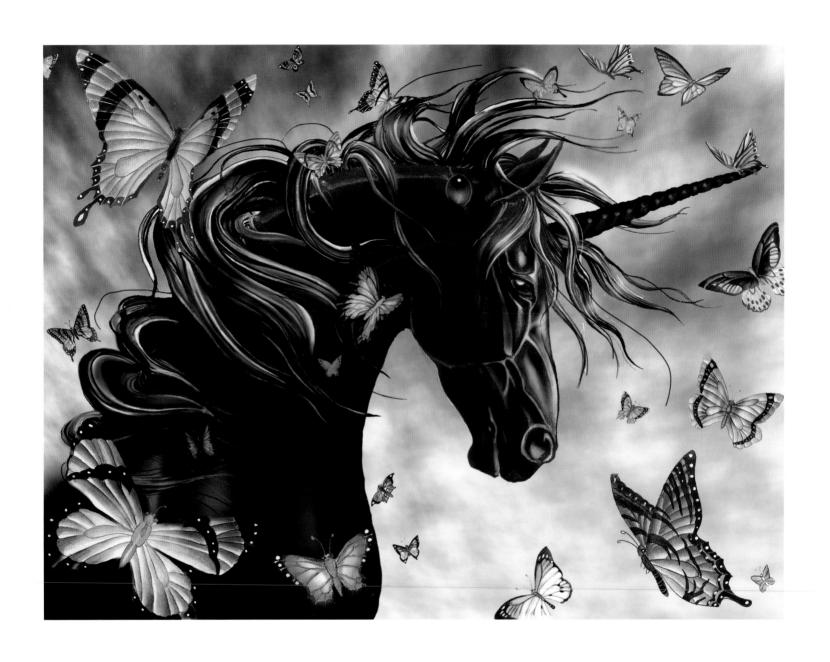

Unicorn Butterflies

This piece was designed as a postcard, but it took me almost as long to finish it as a full-sized piece would have. I had a lot of trouble getting the horse's head in the proper position, and blue skies have never been my strongest suit.

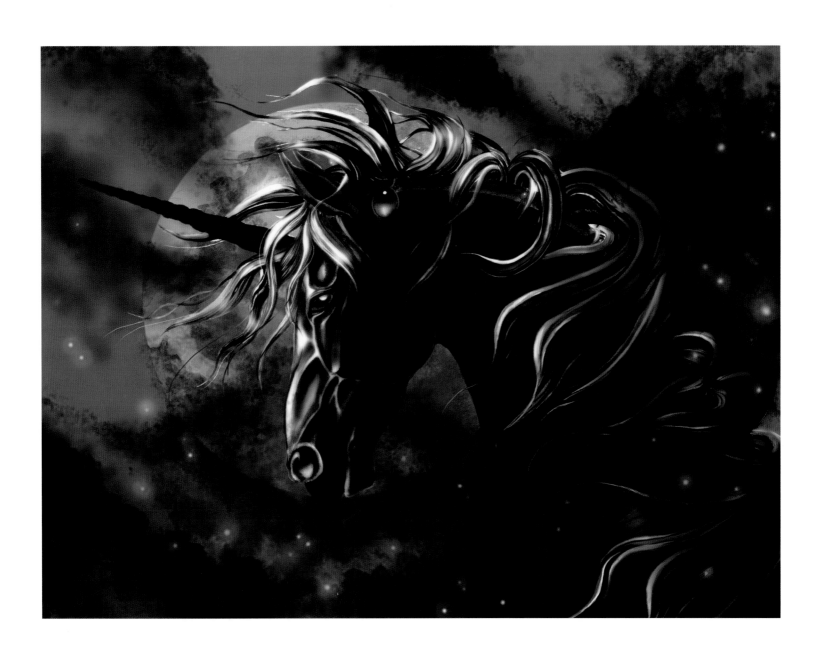

Unicorn Moon

This piece, like *Unicorn Butterflies,* was designed as a postcard, but this one didn't take as long as *Butterflies* to complete because I am used to painting dark backgrounds. The little sparklies were difficult, however. Painting bright touches on a dark background isn't as easy as you might think!

117

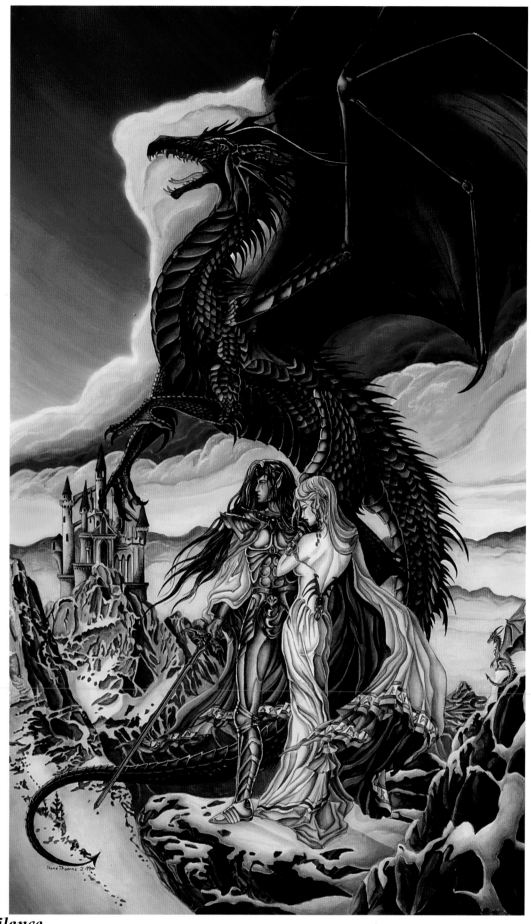

Vigilance

I had to restart this piece seven times, and it was the cause of the only temper tantrum that I'll ever admit to. Nothing on this piece seemed to work right, and during one of the attempts, my cat *Shadowfax* actually spilled my paint water all over it. Eventually everything did come together, and after it was finished, I was able to forgive my evil, evil cat. Every scale on the dragon is hand painted, one by one. It's enough to drive anyone crazy.

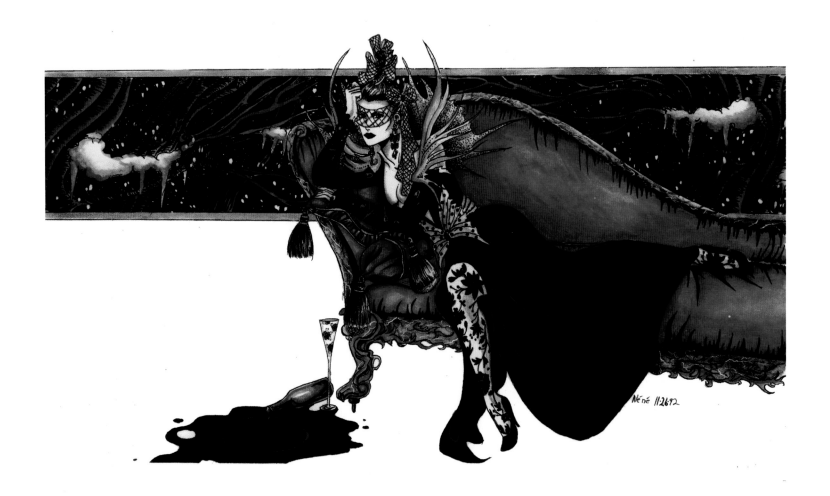

Winter

Gray skin isn't the easiest thing in the world to paint correctly. Achieving a cold look without making the figure look dead requires a very delicate balance. This was the first piece that I had ever painted with grey skin, though I have done it several times since, for example, in *Faery of Ravens*, *La Victime*, and *Hope*. The figure in this piece is named Edaria, and she is another character from my story.

119

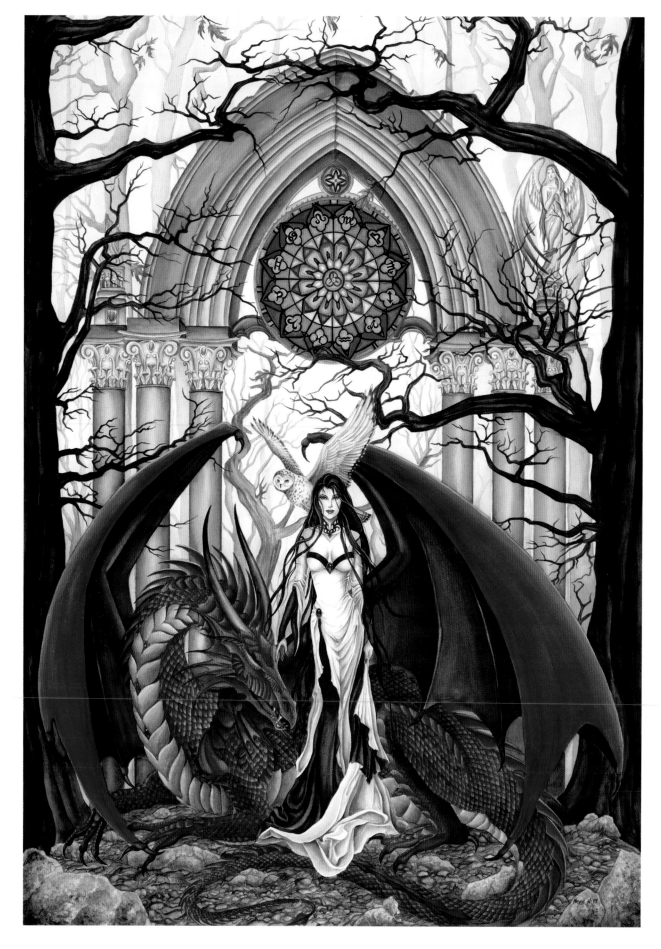

Wisdom

The background for this piece was inspired by the painting *Cloister Cemetery* in the *Snow* by Caspar David Friedrich. I love that painting, and I used it as a reference as I painted this piece. This is one of the largest paintings that I have ever done. It took me over six weeks to finish it.

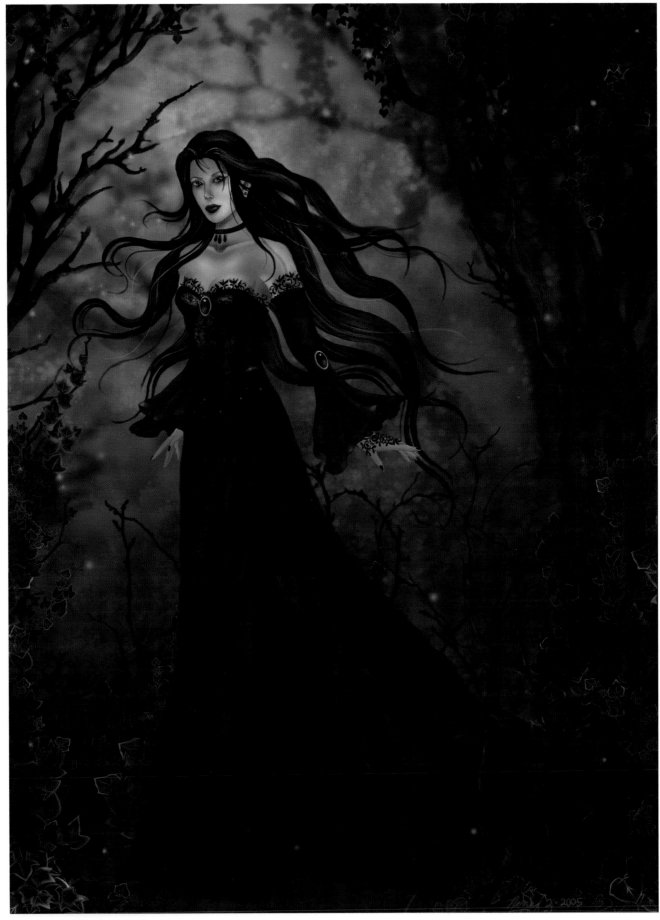

Witchwood

I finished this piece just as the deadline for this book approached, and I was feeling pretty good about it, until I called Steven in to take a look at it. He said, "I really like it, but it reminds me of the cover of a V.C. Andrews book." I took a second look and darn if he wasn't right! It's the lighting that gives it that look. Lighting a face from underneath gives it a distinctive look that you usually see on the cover of gothic horror novels.

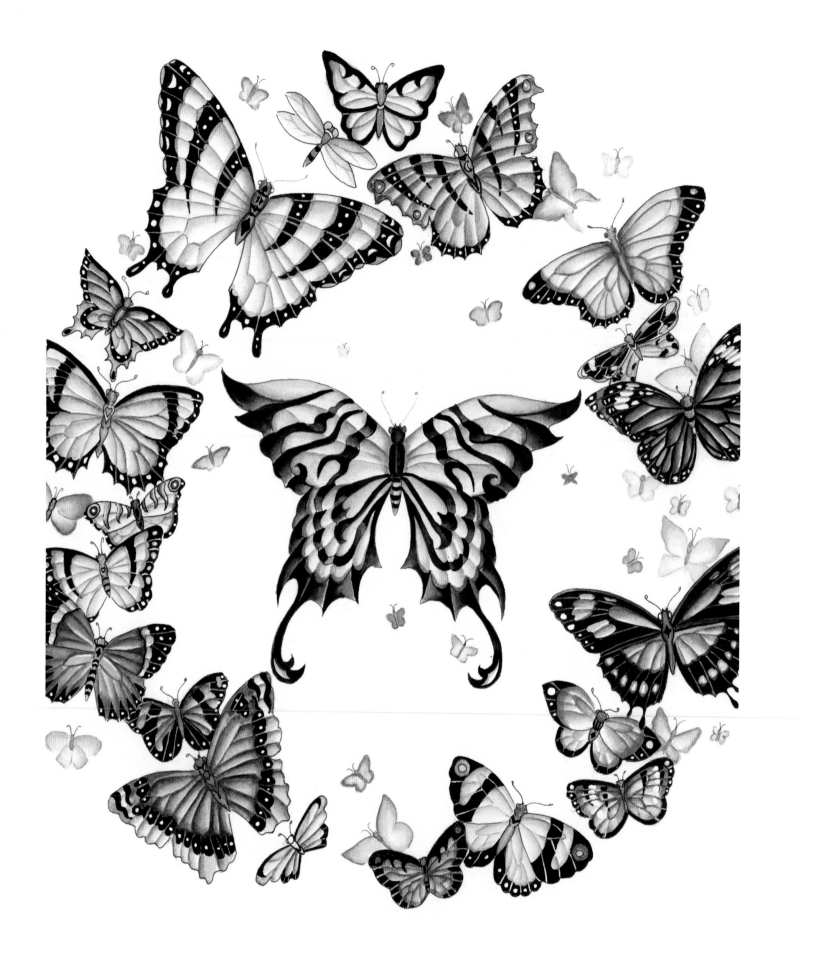

Yellow Butterfly Ring

Both the *Yellow* and *Dark Butterfly Rings* were collaborations that I did with my sister, Ann-Juliette. She drew the original sketch, and I painted it. Then we released the images as stickers. Ann-Juliette has such a great eye for detail that I hired her as my art assistant, and many of my current works incorporate her ideas and designs.

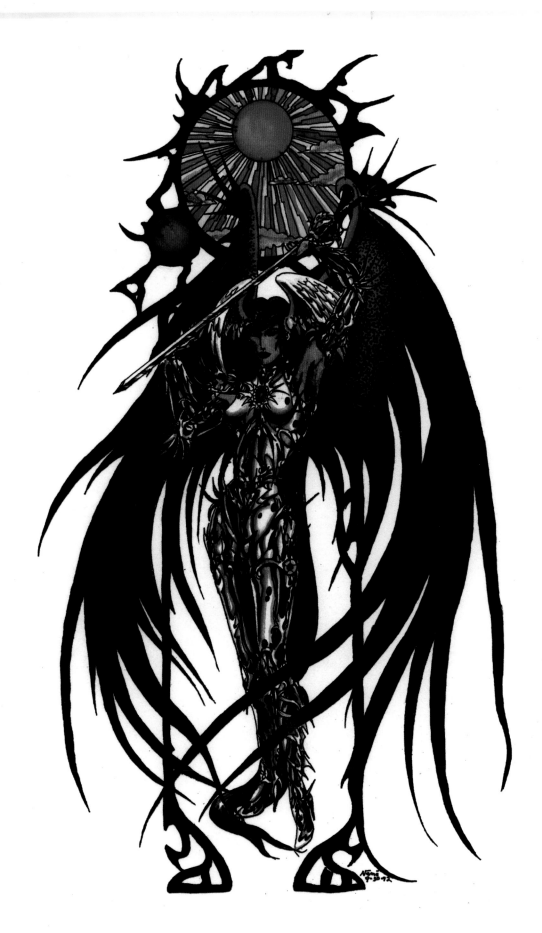

Zarryiosiad

Zarryiosiad is a hand-colored print of a character from my story. This character is the one that begins the epic, thousands of years before the events in my story take place. She created an empire by conquering an entire continent and bending it to her will. Thousands of years later, every noble bloodline in the empire originates from her.

Some General Advice for Aspiring Print Artists

At almost every show I attend, people ask me for advice. Some questions I can't answer, as I decided a long time ago not to pursue contract work. But some advice I can give...specifically, how to make your work appeal to the broadest audience possible. The tips that I have written aren't a magic formula and in no way guarantee success! But, if you follow them as much as possible, you will find that your work will reach a larger audience...and that can translate directly into sales.

1) Avoid nudity in your artwork as much as possible.

Hint at sexuality, make the people in the piece tease, but don't show anything. Intellectually, people understand that nudity in art is a time-honored tradition, and that just because a piece features nudity in it, that doesn't make it smut. Unfortunately, people are also sensitive to what their friends and family will think, and most will err on the side of caution. So while they may appreciate artwork that features nudity, they won't hang it on their walls for fear of offending someone. Simply put, that means you lost a sale. Even worse, some art shows will not even allow you to display your art if you feature nudity. Some will, but will place your work in a closed-off area! The object is to display your art to the maximum number of people possible, not to be placed in a closet for fear of offending people! If you absolutely MUST have nudity in your work, try to make it as tasteful as possible. The more graphic or shocking the work gets, the smaller your audience becomes.

2) Make your characters as generic as possible.

In order to sell as many prints as possible, you have to make your image appeal to as many people as you can. People are more likely to buy a print from you if they can see themselves or their character in the image you have created. That means you have to paint generic characters. Say you draw a beautiful woman that appeals to everyone. The more specific you make the character, the more it will appeal to a specific crowd and the less it will appeal to a general crowd. This is absolutely impossible to avoid! Simply choosing a hair color will lose a percentage of your audience. For example, people that are partial to redheads won't buy pictures of brunettes or blondes etc. You can't avoid that! But don't compound the problem by giving her a tattoo and a nose ring, and putting her on a motorcycle. Motorcycle enthusiasts will love the piece: the

rest of the audience won't.

3) Ugly doesn't sell!

When you create a character, make him or her as beautiful as possible, and pay special attention to anatomy! In fantasy art, people are looking for an ideal representation of the things that they like, especially Roleplaying gamers. People never think of their characters as being ugly or fat or the like. Every character out there is a supermodel or bodybuilder by day, gypsy sorceress with wolf or raven familiar by night. That means that they want perfect representations and it is up to you to provide them. The single most import feature to get right is the face...and more specifically the eyes. The first place people look when seeing a print for the first time is directly in the eyes. After that they will take in the rest of the work, but if the face is flawed then most likely people will remember it and not buy the print. So take time in creating a face. A beautiful face can hide a multitude of sins.

4) Display your work in as professional a manner as possible.

I asked my husband to address this particular point, as he is not only the one responsible for matting and framing my work, but he also arranges my displays at every show we attend. Here is what he said:

Presentation can be vital in the way people perceive your work, and first impressions are everything. If a person approaches your display and sees loose prints hung by bulldog clips, more often than not they are going to walk away. The same thing applies to matted prints: if you mat your prints, make sure that the mat work compliments the piece and doesn't detract from it. You don't have to do fancy cuts, but putting a lime-green mat on a red painting is not good. And make sure your cuts are clean! Ragged mats detract from a display just as much as using bad color selection!

Three people go to a job interview. All three have the exact same qualifications, from the amount of experience, to the amount of schooling. All three of them look exactly alike, except for one thing; the way they dress. The first person is wearing mismatched clothes that haven't seen a washing machine for weeks, let alone an iron. This person has taken no pride whatsoever in his own appearance, relying on his personal experience to get him the job.

The second person arrives for the interview wearing

a full tuxedo (including tails and a top hat) that is glittering with rhinestones. He is immaculately dressed, but looks like a ringmaster at a circus, or at the very least, an ice skater. His qualifications are great, but he just looks gaudy.

The third person arrives for the interview looking like a model in GQ. He is stylishly dressed, but not overwhelmingly so. He has broad shoulders, and the cut of the jacket emphasizes this, without screaming it. Overall, he is the most professional looking interviewee of the group.

Who would you hire? In a perfect world, you can hire any of them and you would be fine. Unfortunately, this is not a perfect world, and image is everything. Who would you want to represent you to the public; the dirtbag, the peacock, or the professional?

The art world is exactly the same way. Artwork that is presented in a ragged, dog-eared mat that uses uncomplimentary colors just looks unprofessional, no matter how good the print itself may be. I have seen very good artists get overlooked at convention after convention, simply because their displays look sloppy.

However, going to the opposite extreme is also bad. Cutting a fancy mat that uses the finest materials is great, unless it overpowers the piece to the point that all you can see is the mat, not the art. People will not pay out their hard-earned money for something that looks horrible on the wall, no matter how well it may be cut

.

The best mat is tastefully cut without being too plain. Ideally, you should use the artwork itself to plan out the mat. For example, look at the general flow of the piece. Does the action flow from one side of the piece to another? If so, perhaps a ray pattern or a diagonal cut might bring it out a little more. Is the action centered? If so, maybe a centered pattern might be in order. Is the piece elegant or flashy? Elegant needs a plain cut - perhaps a 3-D Double Bevel - while a flashy piece could use zigzag offset corners. The possibilities are endless. There are other rules for displaying your art in a professional manner. Make sure that you don't crowd your display. If you have a lot of pieces to sell, pay for the extra panels. Crowded displays are very difficult to look at, and most people won't take the time.

5) If you are painting mythological creatures, stick to the ones that everyone knows.

Fantasy creatures are very popular with the buying crowd. However, certain creatures are more popular than others, and you have to cater to the buying public. Dragons are perennial favorites, as are fairies, mermaids, pegasi and unicorns. Less popular are griffons and hippogriffs. Western dragons (like the ones Elmore paints) are more popular than Eastern Dragons (Chinese Dragons.) This rule applies to animals as well. The most popular creatures among fantasy art collectors are ravens, wolves, falcons and hawks, horses, and dolphins. For some odd reason, giant cats are not as popular, unless you go for the really exotic breeds: white tigers, snow leopards, black panthers etc.

Keep this in mind when you are painting your main figure as well. Elves and humans sell quite well, dwarves and halflings don't. Centaurs and other half human figures (or anthropomorphic creatures, i.e. "fuzzies") have a market, but the vast majority of buyers aren't interested.

6) You can't fool the buying public. They are smarter than you think.

The average buyer knows at first sight whether or not they like a print well enough to pay good money for it. You can tell them all about the inherent symbolism and mysticism and the like that you have placed in the image, but all they are really concerned with is whether or not the print will look good in their house. The fact is, almost every single print that you sell is an impulse buy. A potential customer already knows if they are interested in buying a print of your work. If they are hesitant about buying from you, usually it is because they are wondering if they have the money or the room to display it or a way to get it home…etc. It normally has nothing to do with the print itself. If a print isn't selling, then YOU did something wrong and it is up to you to correct it.

7) Paint in bright colors. It makes your display stand out.

Sometimes, people can be like crows. They are attracted to shiny objects and are naturally drawn to them, so if you paint in bright colors they will naturally be drawn to your display. If you normally do paintings with darker themes, a single bright painting can be enough to bring people in to your display. But when you hang your work, make sure that the brightest piece is hung as close to the center as possible and the rest arranged around it. Bold colors make a statement about your work, and people will respond.

8) If you advertise a print run as a limited edition, keep it that way. Reprinting will cost you customers. Of all of these bits of advice, this is the one that I have the hardest time mentioning, simply because so many people in our career field are guilty of it. It takes a long time to build up a good clientele. Once you have "regulars" you will find that they tend to spend more money than other people. The problem is trust is a very difficult thing to earn, and you can lose it forever in an instant. If you tell people that there are only going to be so many prints in an edition, then stick to that, even if doing so will cost you money. If you think an image is going to be popular, there are ways to have your cake and eat it too. As long as you tell people UP FRONT that you reserve the right to reprint an image or have an open edition, then there is nothing wrong with reprinting a sold-out edition. If one of your customers finds out that you have reprinted a sold-out edition dishonestly however, you will lose not only his trust but all of his future business as well. "Prefer a loss to a dishonest gain; the one brings pain at the moment, the other for all time."

9) Find ways to cut costs, and keep your prints as cheap as possible. No matter how good your art may be, if it is too expensive for people to buy, they won't buy it. "Quantity has a quality all it's own" is very true when it comes to art: selling ten prints at $10 each is much easier than selling one print for $100. In order to keep the price of your prints from becoming too high for people to afford, you need to learn how to cut costs. Buy a mat
cutter and learn how to mat your own work. Buy your supplies (frames, glass, matboard, tape, EVERYTHING) from wholesalers whenever possible. Ship things via U.S. Post a couple weeks in advance to save shipping. Anything you can do to bring down your costs is savings that you can pass on to your customers. Don't lose your shirt over it though! If you have to charge more for a print, then do it and don't think twice about it. You are in this to make money after all, and taking a loss is defeating the purpose.

10) Never fall in love with your own work. Criticism is the best way to learn where the strengths and weaknesses in your work are. So don't take it personally if someone criticizes your art. You will learn wrong in the others. As I mentioned earlier, you can't fool the buying public. THEY will tell you where your work is good and where it isn't. There is a caveat to this rule: more from people that point out the flaws in your work than you will from those who compli-

ment it. Also, if you are mailing 10 pieces of art to shows and only one piece is selling consistently, try to figure out what you did right in that one piece, and what you did wrong.

10-a) Artists are not the best judges of their own work. You will find that prints that you think are perfect don't sell as well as you think they should, and prints that you think are utter crap sell as fast as you can mat them. Don't get discouraged by this! Do your own thing and let the sales take care of themselves.

11) Size matters. People equate size with value. The larger a print is, the more you can charge for it. So no matter how good and detailed a print is, if it is smaller charge less, if it is larger, charge more. There are exceptions of course! A small original is worth more than a large print to the buying public. A large open-edition print isn't worth as much as a small, limited edition print.

I hope that this information can help those of you who are wondering what it takes to become a print artist. It took me a long time to learn some of the lessons that I have posted here. So I hope you can profit from them! Good luck!

**Nene Tina Thomas &
Steven Plagman**

SPECIAL THANKS TO:

My wonderful husband Steven who has always believed in me even when I doubted myself. The employees of Nene Thomas Illustrations Inc.: Ann-Juliette Thomas, Jan-Annette Johnson, and Darlene Bryant. In particular, I would like to thank Ann-Juliette for the beautiful inks that you will see throughout this book. She has become an indispensable part of the artistic process, and without her this book would be greatly lessened. I would like to thank all of my other brothers and sisters, Chance, George, and Yvette, as well as my parents, John and Patricia Thomas. I would also like to thank Harold and Supattra Plagman, my in-laws, for giving us all the support that we could have asked for throughout my career. I would like to thank the many artists that have inspired and befriended me over the years. Time and again the examples you've set have made me challenge my ideas of what can and can't be done.

AND VERY SPECIAL THANKS TO:

Norm and Leta Hood. By supporting me and publishing this book, you have made a lifelong ambition a reality. Your valuable insights and steady encouragement has made this book better than I imagined it could be. For that you will always have my gratitude.

INDEX